REFLECTIONS OF THE BREAST

Francis P. Arena, M.D., F.A.C.P.

Tanya Bastianich Manuali, Ph.D.

Brick Tower Press
New York

Brick Tower Press
1230 Park Avenue, 9a
New York, New York 10128

Library of Congress Cataloging-in-Publication Data

Francis P. Arena and Tanya Bastianich Manuali

Reflections of the Breast: The History of Breast Cancer Through the Eyes of Artists Through the Centuries. Insight and brilliance of countless artists who told the story of all those who have suffered from this disease and documented and possibly foretold the development of the therapies that we have today.

p. cm.
ISBN 13: 978-1-883283-76-6
1. Woman's Health, breast cancer.

Nonfiction
Library of Congress Control Number: 2010934394
First Edition, October 2010

To our mothers, Rose and Lidia,
and to all the mothers who love unconditionally.

ACKNOWLEDGEMENTS

There are many people to whom we owe a great deal of thanks for their efforts, support, and encouragements. The thought behind Reflections started almost eight years ago in 2002 at the Breast Cancer Education Day of the Sass Foundation for Medical Research. Frank had asked Dr. Maria Theodulou, of the Memorial Hospital Sloan Kettering Cancer Center, to speak and conduct a workshop for patients, where she showed the image of Rembrandt's Bathsheba's Bath. Though the story behind the image was familiar to Frank and he had read the letter to the Editor in the *New England Journal of Medicine*, seeing the blown up reflection of the left breast in the painting seemed to ignite a whole sense of questions, intrigue, and a passion to know more, not just about this painting, but about other paintings and statues that might reveal the same things. It is here that the story begins.

In the ensuing years, with the help of students and volunteers, the panorama of art began to take shape. By the best of fortune in 2008, Frank was able to lure Dr. Tanya Bastianich Manuali, an art historian trained at Oxford, under the spell of the tale of every woman and the fight against breast cancer.

For two years now, we have pieced together a fabric of images, documents, statues and pictures all reflecting the battle that women and men have been facing against breast cancer since the time of the Egyptians, all documented by the quill, the brush stroke, and the chisel of incredible artists. We have to thank our families, Tanya's loving husband Corrado and beautiful children Lorenzo and Julia. For all of their support and encouragement, Frank's family: a wonderful wife Kasey and children Jillian, Brittany, Frankie, Chris, Joey and of course, Willie. We need to remember those that love us the most who have put up with our endless emailing and writing until all hours of the night, all in the hope to report on an amazing story that has been starring at us all for centuries, reflecting a saga that has taken 5,000 years to evolve.

To Aydin and Stephanie Caginalp for introducing us to John and Betsy Colby of BrickTower Press. John and Betsy had the courage to listen and the faith to let this story be told while others would let it sit quiet and never see the light of day. To Jane Dystel, our agent who helped tie all the loose ends together and be our cheerleader when we needed one.

But lastly and most certainly, not the least, we need to thank the patients. We need to thank every woman and every man that has ever had to face this horrid disease. This is their story. It is their conquest. This is the reflection of their suffering, their endurance, their overwhelming need to be seen, heard, and taken seriously. Reflections is their saga. It reflects their coming victory , which cannot come soon enough. Thank you.

Francis P. Arena, M.D., F.A.C.P.
Tanya Bastianich Manuali, Ph.D.

Much has been done in contemporary times to bring awareness and possibly a cure for breast cancer. Organizations, campaigns, marathons, research, survivor groups all point to a big pink ribbon. But is breast cancer, a disease that afflicts millions and attacks the very essence of being a woman, a recent phenomenon?

Not so according to *Reflections of the Breast* an extraordinary book documenting the research and collaboration between Tanya Bastianich Manuali, Ph.D. and Dr. Francis Arena. This dreadful disease is as old as our history. In this book *Reflections of the Breast*, through art, the existence of breast cancer through the ages is documented. Each image evokes the time, society, and medicine. The paths of breast cancer in each work of art becomes obvious as the eye of the artist accurately captured it.

"This beautiful and informative book is a tribute to all of those who fought this battle, but especially to the survivors ... an extraordinary book for living today."
—Lidia Bastianich, Host of the Public
Television series *Lidia's Italy*, chef, restaurateur and author.

"A fascinating and provocative journey back in time. Dr. Francis Arena and Tanya Bastianich Manuali, Ph.D. create an insightful and visual plateau as they explore the illustration of breast cancer and breast disease beginning with the earliest centuries after the birth of Christ. Reflections of the Breast reads like a delicious novel, but is all true and filled with astounding information."
—Valerie Smaldone, Media Personality
and Ovarian Cancer patient advocate, speaker.

CHAPTER ONE: INTRODUCTION

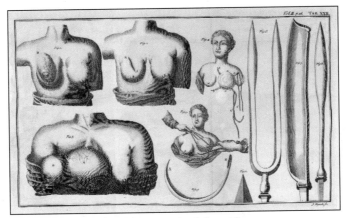

L. Heister, *Latent or Occult Breast Cancer.*
Photo Courtesy Wellcome Library, London.

The breast: bosom, bust, chest, front, mammary glands, mammilla, nipple, teat, udder and even the more vulgar tit. Perhaps, there is no more sensual part of the human body than a woman's breast. Throughout the centuries, a woman's breast has come to symbolize motherhood, fertility, passion, virtue, beauty, warmth, compassion, perfection,

prosperity, femininity, and of course, sexuality. It has been the center of thousands of pieces of art and statues. It has been the focus of literature since the beginning of time. It has turned our imagination to flights of fantasy and desire ranging from passion and lust to that of adoration and prayer. The Romantic English poet Keats (1795–1821) once wrote:

"'Tis vain away I cannot chance

The melting softness of that face

The beam'ness of those bright eyes

That breast, earth's only paradise!"

Even the Austrian neurologist Sigmund Freud (1856–1939) had something to say about the dynamics of the image of the female breast: "Love and hunger meet at a woman's breast..."

With all of the descriptions of the beauty and the beguiling presence of the female breast, there is something missing. Something that could lurk inside of every woman. Something that has been a plague of mankind since recorded time. Something so dire, so terrible, so destructive and so overwhelming as not to be mentioned. Or has it? Could artists through the centuries have conveyed more than the accolades of the female breast? Could they have depicted more than the beauty, the sensuality, the passion and the sexuality of this remarkable part of the human body? That *something* we are referring to is breast cancer, a disease that has been struggled with since the time of the pharaohs. Breast cancer

is not just a twentieth century disease. It has been recognized and dealt with in very important ways throughout the centuries.

It is said that art expresses the human experience. Art reflects the human saga in the totality of its range of emotions, whether it is beauty or love, passion or hate, joy or sorrow, disease or health, death or life. It should be of no wonder to consider that artists were aware of this demon potentially lurking within the female breast as well as they were aware of the breast's beauty. Could artists through the centuries, aware of this disease, have given us a reflection of what it was like to have been a patient with this disease? Could they have been telling us what it was like to be treated or what the treatments for this disease really were and felt like?

The story that we are about to weave is the story of every woman. It is a story that has taken centuries to evolve. It records in words, pictures, sculpture, votives, and most recently, photographs, the timeless battle that each woman that has ever faced breast cancer had to endure. It is a pictorial history, a reflection, of what artists throughout the centuries saw as the face of breast cancer.

Each piece of art is a time capsule snap shot of what was the human experience of that time. These pieces of art not only let us look at the individual portrayed on its canvas or in stone but also let us look inside the face of the model that was used and see within the soul. We get to look at the fright, the anguish, the denial, the fortitude, the perseverance, the fear,

and the resolution and thankfully for some, the victory over this horrible disease. When taken as a whole, the story that these artists tell also mirrors and perhaps foretells, of the treatment that has also evolved during these periods of time.

During the latter part of the twentieth century, many art historians and interestingly, physicians have made comments concerning individual pieces of art that will be described in our later chapters. Some have commented on the pure artistic qualities of the art. Some have given their ideas as to the possible diseases that were being represented. The purpose here is not to dwell specifically on just one piece of art but rather to see where that piece of art stands in relationship to the times and circumstances in which it was created. Oncology is a rather new subspecialty of medicine. In the United States, it was certified as a subspecialty in the early 1970's. The concept of a cancer or tumor was thought to be an imbalance between the humors or fluids of the body. The Greek physician Hippocrates (460 BC- 370 BC), known as the father of medicine, thought this was from black bile. This concept of the possible cause of this mysterious disease and even its treatment prevailed for centuries. It is of no wonder that for many artists things that were tumors might not exactly be cancers by modern day analysis. What is striking is the recognition that many of these tumors and cancers took place in the breast. The focus on the diagnosis, treatment, and the individual endurance that these diseases represented is the image that we will portray.

Each piece of art is a milestone in the propagation of a new set of reflections. Each of

these is a new image dependent on the image that came before it. The story that we are about to tell did not occur overnight. It started in the most ancient of times when superstition and mysticism ruled the conscious thought. It started when there was the ominous diagnosis of a disease without known therapy. It follows the path throughout the advent of medical science. It peeks its head from under the resolute smile of those knowing their fate. It hides beneath the gowns and the exposed breast of those that were loved. Its treatment becomes the voice of torture and the supplication of saints. Its conquests become the images of miraculous interventions. The stories of those inflicted become the fodder of mysterious tales. The looming presence of a modern medicine becomes the backdrop of recounts of courage and of their suffering. By the time of the coming of the twentieth century, all eyes are on the science and not the allegory of this disease. By the latter part of the twentieth century, the reflection is now a self proclaimed victory over this dreaded disease. No longer is the patient hidden behind the mask of an unspeakable affliction. The images of those afflicted become a part of their healing and a proclamation of their survivorship. Has the artist caught up to the physician? Or has the physician finally caught up to the artist in treating this plague of the centuries?

Reflections of the Breast represents the insights of a physician whose interest is in breast cancer and an art historian whose interest is in the social meaning behind art. Each reflection, images that you will see, gives us an understanding about those that came before and

those that we will encounter. It is about the history of medicine and the triumph of science. It is about the falsehoods of the black bile and the interplay of molecular biology and genetic predisposition. It is about the artists who wove together a matrix of illusion, an open display of a disease that otherwise was unspeakable. Their work consisted of beautiful texts with ominous projections; of beautiful images hiding a ravenous disease. Some of these artists modeled their work so cleverly and yet so blatantly as to have some believing there might be a mistake in their craft, only to be found later depicting in such vibrant detail the pathologic presentations of this silent intruder. All of this work culminating with the artist as patient and as a survivor. *Reflections of the Breast* tells us the story of every woman that has ever faced this tragedy and hopefully every woman that will be cured. *Reflections of the Breast* is a tribute to the human spirit and a testimony that hope, prayer, and science can lead us to a world free of such images.

Join us now. We begin our journey in the shadow of the temple of Imanhotep outside of Luxor. It is 1500 BC and the world is laden with mysticism and many unknowns. But none is more freighting than that of breast cancer!

CHAPTER TWO: ART OF MEDICINE IN ANCIENT TIMES

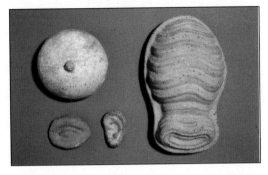

Etruscan Votive Sculpture, terracotta model of a womb, breast, eye and ear all dedicated at the shrine of a healing god.
Photo Credit: The Trustees of the British Museum/Art Resource, NY

O n a long and dusty road outside of Luxor Egypt, a Connecticut born American is about to make the purchase of a lifetime. The year is 1862 and the man is Edwin Smith. He is described as being an adventurer, a moneylender, and a dealer in antiquities and possibly dabbled in antiquities fraud. But on the day that he met Mustafa Aga, a dealer in antiquities, a.k.a., a tomb robber, he would be struck by a papyrus that he found utterly fascinating. He purchased this papyrus but realized that there were fragments missing. Two months later, by the same Mustafa Aga, Smith purchased the second part of the same document.

The papyrus is comprised of seventeen pages. A total of 377 lines on the *recto* or front of the document and 92 lines on the *verso* or back of the papyrus. The dating of the papyrus is

of some interest. It is believed that the Edwin Smith papyrus dates back to 1500 BC but it seems to be a copy of a more ancient text dating as far back as 3000 BC. Imhotep, a 3rd dynasty physician who was eventually deified, has been credited as being the original author. He is considered to be the father of ancient Egyptian medicine. Interestingly, in 2700 BC, the first known surgery took place in Egypt. The papyrus is believed to have come from the tomb of a physician in Luxor. It is totally different from other papyri, which usually contain comments on giving remedies or potions for certain diseases that had already been diagnosed. Unlike other papyri, there are no magical formulas or spells to be recommended. The Edwin Smith papyrus gives the reader a totally different view. Here we have forty-eight different cases, mostly trauma, each case approached from the viewpoint of how a physician can diagnose a patient and then, how to treat the individual entity. Many scholars believe that this papyrus was a surgical manual. It was ancient Egypt's answer for the 21st century's Washington manual, the bible of the medical world.

Edwin Smith tried to translate the papyrus, but he never published his results. It wasn't until 1930 when James Breasted finally translated the text into English. Though most of the cases represent surgical approaches to traumatic injuries, it is Case 45 which I would like to bring to your attention. But before we do that, it is important to understand the totality of thinking about disease and the approaches to treatment that the ancient Egyptians had. We need to place in context the dynamics between the individual person and how they per-

ceived health and disease. Case 45 is indeed an eye- opener but until you can stand in the shoes of an Egyptian of the third dynasty, the full thrust of what the patient and the artist experienced cannot be fully appreciated. Let's go now to the times when all of these writings where taking place.

Ancient Egypt was a rather intimidating place when it came to health and diseases. The fear of illness, whether it be from trauma or infectious etiologies, was a main concern for the average Egyptian. But other causes of illness such as diseases concerned with childbirth, systemic illnesses such as arthritis, kidney disease and cancers or tumors where also problems that were faced even in ancient times. The concept of disease was both a compilation of crude science and mysticism. For illnesses that were the direct result of injuries or trauma, the cause of disease was quite direct. The Egyptians had a number of cleansing herbs and splints to fix their day-to-day problems. The Egyptian household of a wealthy pharaoh or official might well have had its own first aid kit to deal with these problems. But when it came to other diseases, those to which there was no known visual cause, we had a whole new set of rules. The Egyptians lived in unity with their gods. There were gods for every occurrence or problem. Diseases that could not be interpreted by mere physical contact were ailments caused by a misbalance or anger of one of those gods with the individual person. For ancient Egyptians and to the ancient Greeks, health was a balance of the humors or fluids of the body, and illness was an imbalance of these humors. These bodily fluids were

blood, yellow bile, phlegm, and black bile. Even Hippocrates, the father of modern medicine, believed in this concept of the humors of the body. The physician of ancient Egypt had a dual role. He was both the custodian of the science that they had, as well as the bearer of magical spells and rituals that would set back the proper relationship with the angry gods. The physicians practiced their medicine in temples, combining both religion and science under one roof.

When a person fell to a certain illnesses, they went to see the physician to rid themselves of their demons. Through ritual sacrifice and prayers the patient reestablished their relationship with the gods they believed had a major role in daily occurrences and certainly in the causes or reasons of illness. There were many processes for this healing. They included cleansing rituals with water, possibly reflecting the primal relationship to the Nile as well as the Egyptian obsession with cleanliness as a cause of disease. Often there were potions made from the different internal organs of animals, these symbolizing the disease that the physician thought he was treating.

One of the most fascinating and prevalent techniques for healing that was practiced throughout the ancient world not only by the Egyptians but also by the Greeks had to do with the healing power conveyed in dreams and the recording of healing or solicitation to the gods for intervention by the making of votives. To the ancient Greeks, Asclepius, the god of healing, was honored throughout the countryside with temples. When a patient suffered

from an ailment that could not be readily understood or for which there was no obvious treatment, such as a cancer, the patient went to one of the healing centers or temples known as Asclepions. The patient went to these temples in sort of a pilgrimage not unlike what we would see today in patients going to Lourdes in search of a miracle. These temples were usually in very beautiful areas that nurtured the patient's soul as well as healed their body. The patient would be given sumptuous food, purifying liquids, be engulfed with music and poetry, all in preparation for their readiness to be visited by a god or one of his totems in a dream. Therapeutes or therapists would determine when the patient was ready to receive the cure of their disease by the visitation in a dream. The patient would be taken to the Abaton, an incubation room where the patient would pray and await the visitation of Asclepius in their dreams. Initially, the Abaton were found in caves but eventually were placed in temples. Patients would claim spontaneous healing from their illness or be given the path or direction for their cure in these dreams. In turn, the patient would then prepare a votive of their illness to record their cure by the healing god. These votive offerings would take the form of a model of the diseased part of the body that the patient wanted to be cured. These votives were then left in the temples as offerings to Asclepius.

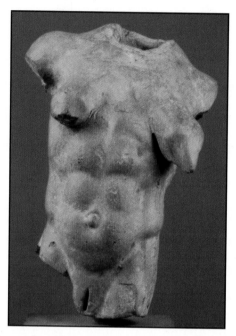

Grotesque torso, breast deformed by a tumor. Terracotta, from Izmir, Turkey. Photo: Christian Larrieu.
Photo Credit: Réunion des Musées Nationaux/Art Resource, NY.

The Romans adopted the cult of Asclepius but changed his name to the Latin, Aesculapius. In ancient Rome, the use of votives took on an even more dynamic position. Both cremation and burial were accepted ways of honoring the dead. Towards the first century AD, burial became a more prevalent procedure especially for the wealthy or famous. In the tombs of these people, votives would be placed commemorating the diseases that the de-

ceased had endured. In the Roman temples honoring Aesculapius, votives were hung along the walls of the temples, possibly symbolizing those that had been already cured but also at the foot of the altars to the gods, perhaps representing those that still needed their intervention. In the absence of any useful therapy, the suffering would find both solace and, hopefully, miraculous healing through prayer and votive offerings to Aesculapius.

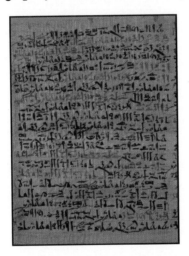

Edwin Smith Papyrus, Case #45, Rare Book Room, New York Academy of Medicine Library.
Photo Courtesy The New York Academy of Medicine Library.

It is here that we can now relate the Case 45 of the Edwin Smith papyrus. The circumstances and opportunities for healing can be understood. The options for therapy were limited to that of votives begging for divine intervention. The art that we see represents not

only artistic expression of the diseases confronted, but uniquely represents the only possible therapeutic intervention.

James Breasted translated Case 45 as follows:

"Case Forty-Five: Instructions concerning bulging tumors of the breast.

Examination: If thou examinest a man having tumors in his breast, (and) thou findest that swelling have spread over his breast; if thou puttest thy hand upon these tumors, (and) thou findest them very cool, there being no fever at all therein when thy hand touches him; they have no granulation, they form no fluid, they do not generate secretions of fluid, and they are bulging to thy hand.

Diagnosis: Thou shouldst say concerning him: One having tumors. An ailment with which I will contend.

Treatment: There is no treatment. If thou findest tumors in any member of a man, thou shalt treat him according to these directions."

Gloss: " Bulging tumors on his breast" means the existence of swellings on his breast, large, spreading and hard; touching them is like touching a ball of wrappings; the comparison is to a green hemat fruit, which is hard and cool under thy hand, like the touching those swellings which are on his breast.

These are the directions to be followed by physicians for centuries. When diagnosing a tumor or cancer of the breast the only therapy to be considered is NO therapy! There is no treatment. There are no options. Hippocrates first used the word cancer in about 460 BC from the Greek term karikinos referring to a crab. This was probably because of the projections of a tumor invading normal tissue resembling a crab. He wrote in 400 BC: "It is better to give no therapy in these cases of hidden cancers (non-ulcerating breast cancers). Treatment causes speedy death, but to omit treatment is to prolong life."

What could a woman (or man) have done when confronting this disease? What hope or recourse could they have followed? Medicine was a short list of herbal remedies and crude surgical maneuvers with no knowledge of infectious disease, no real anesthesia, and ultimately, the return of this hated disease.

There were surgeons who were attempting heroic surgery for breast cancer even in 480 BC. Herodotus, a historian of the wars between Greece and Persia, claimed that Democedes, a Persian physician living in Greece, cured the wife of the Persian King Darius of breast cancer. Leonides in 180 BC, an Alexandrian surgeon, described the surgical removal of breast tumors that had not ulcerated even using cautery to stop bleeding and to sterilize the remaining normal tissue. But even these early escapades into the surgical treatment of breast cancer were primitive and cruel by any standards. The words of the Edwin Smith papyrus

and Hippocrates ring loud and clear. There is no treatment. Leave the patient alone, there is nothing that can be offered. Or is there?

The votives that the artist made not only paid offerings to the gods for help. They not only recorded the suffering and prayers of the patient, but they were also both the instrument of recorded time and the vehicle of a possible miraculous cure. The artist gave us a glimpse at what the disease was like but also told us of what the therapy was for ancient peoples throughout Egypt, Greece, Rome, and the Middle East. The reflections that these artists showed us were not just of the offerings of the afflicted but the therapies that someday might come.

CHAPTER THREE: SAINT AGATHA AND THE RELIGIOUS SIDE OF BREAST CANCER

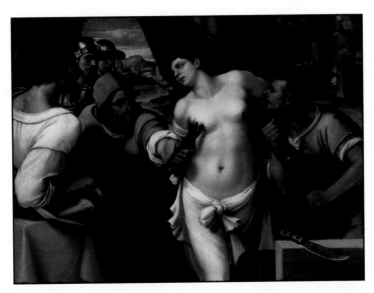

Sebastiano del Piombo, *The Martyrdom of Saint Agatha*, 1520. Galleria Palatina, Palazzo Pitti, Florence, Italy.

Photo Credit: Scala/Ministero per i Beni e le Attività Culturali/Art Resource, NY.

In the Catholic Church patron saints play an important role and pervade religious belief. St. Lawrence, the patron saint of chefs, received his martyrdom being cooked on a grill. Praying to Saint Anthony, the patron saint of lost items might help you find something.

Saint Ambrose is the patron saint of bee keepers and Saint Apollonia of dentists. The list is quite long and the Catholic calendar has a patron saint listed on every single day of the year, barring Holy feast days. Breast cancer is no exception and has its patron saint as well, even though the saint so revered, Saint Agatha, never had breast cancer.

The story behind Agatha, a beautiful and rich Sicilian young woman is indeed a mystical story. It takes place in Sicily in the third century AD. She was consecrated to God at a very early age and vowed to keep her chastity. So here enters the villain of our story, Quintianus. Seemingly, this troubled Roman prefect had the hots for young Agatha. He made many advances to her but was spurned by the young woman. Under the pretext of her Christian faith, Quintianus placed her under arrest and sent Agatha to be put into a brothel run by Aphrodisia and her nine daughters. According to legend, after thirty days in the brothel, Agatha still retained her virtue. Quintianus hearing this and once again asking Agatha to become his mistress, which she refused, sentenced her to be tortured. According to her own accounts, Agatha was placed on the rack and stretched, beaten, whipped, cut, burnt, and finally had her breasts cut off.

She told the judge: "Cruel man, have you forgotten your mother and the breast that nourished you, that you dare to mutilate me this way?" Bleeding, in terrible pain and torment, Agatha was thrust back into her dingy cell to die of her wounds and certain infection and bleeding. According to her own testimony, that same night, Saint Peter visited her and

her wounds were miraculously healed. **In the 17th century painting by Giovanni Lanfranco, a Caravaggio follower,** *Saint Peter Healing Agatha,* **we see the act of divine intervention.**

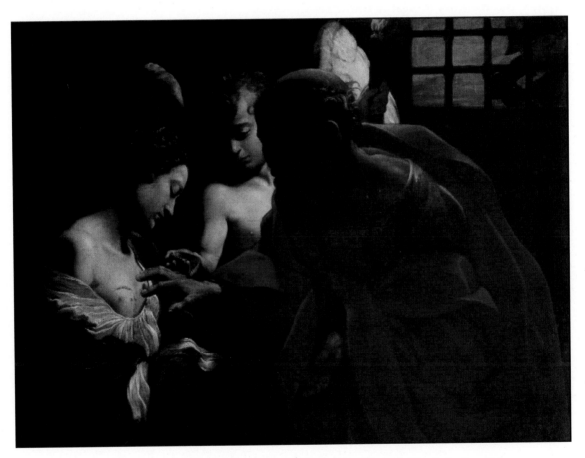

Giovanni Lanfranco, *Saint Peter Healing Saint Agatha in Prison,* Galleria Nazionale d'Arte Antico, Rome, Italy

Photo Credit: Scala/Ministero per i Beni e le Attività Culturali/Art Resource, NY.

The thought that only such a super- natural intervention could bind the wounds and restore the health of someone who has just undergone a mastectomy could not have been more explicit. But the story of Agatha continues.

Quintianus, still obsessed by Agatha and troubled more than ever that she would refuse him even at the price of a bilateral mastectomy, decided to sentence her to death. Now Quintianus being the typical Roman bully, had to do this with the usual tortuous bravado. He ordered Agatha to be rolled over live coals mixed with sharp pieces of broken pottery for good measure. According to legend, as Agatha was being rolled over the live coals, naked, the ground upon which she was being tortured underwent a huge earthquake. As this happened, a wall fell down on the counselor to Quintianus, whose name was Silvain and upon his friend, Fastion, who had presided over her torture. Agatha later died in prison in 251 AD.

The image that is often associated with Saint Agatha comes from Bernardino Luini's *Saint Agatha.*

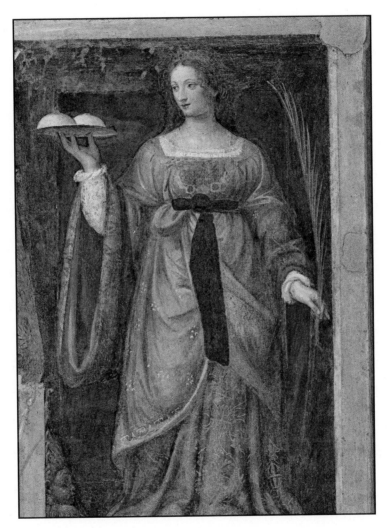

Bernardino Luini, *Saint Agatha*, Chiesa di San Maurizio Al Monastero Maggiore, Milan, Italy.

Photo Credit: Photoservice Electa Mondadori/Art Resource, NY.

Here we see the image of Agatha contemplating her breasts on a standing slaver held in her hand. Interestingly, the shape of the portrayed breasts reminded some of the shape of bells and to others round loafs of bread. Hence, Agatha was named patron saint of bell-founders and of bakers. On her feast day, loaves of bread are blessed. Most recently, Agatha has become known as patron saint of breast cancer.

Truly, this remarkable story is one of devotion, virtue and true divine intervention. Imagine the thought of torture being the removal of a woman's breasts. Mastectomy was the torture. Nothing more ominous or terrifying could any bully conjure. How could anyone dare think that such a hideous act could be the salvation for any disease? How could this action ever be sanctioned as a medical procedure to save a woman's life? Saint Peter himself had to come down and with the help of angels bind the wounds that would actually take the life of Agatha after such a horrible act. Without such divine intervention all would be lost. All of these artists were reflecting this woeful saga. Mastectomy is torture. Without the god's interference, a person would die from this. Sainthood, virtue, and unbelievable resistance are terms that come to mind when faced with the prospect of a mastectomy. To survive all of this would take a super woman, someone whom the gods have surely chosen. Agatha was a superwoman, but this wasn't for every woman. The treatment for even an early breast cancer, if such truly existed in the third century, namely mastectomy, was a terrible thought. When confronted with this option, any woman would clearly see it as a cause of tremendous

torment. Breast cancer was not only a death sentence by itself but the possible treatment, mastectomy, was just as bad. Could the legend of Agatha, as described by these artists, give a ray of hope for anyone afflicted by this disease? Could anyone endure the treatment without the supernatural coming to their aid? Prayer and faith, not science or medicine, were the only true avenues for redemption and salvation.

In the Church of Santa Maria delle Grazie, the same church complex that houses Da Vinci's *Last Supper,* there is another reflection of this divine intervention. This fresco was initially brought to the attention of the medical community in 2006 at the 8th Milan Breast Cancer Conference by Janyant Vaidya in which over a 1,000 oncologists failed to deny his observations. Vaidya pointed out a fresco in the church, *The Madonna Delivers Milan from the Plague* (1631) by Giovan Battista Crespi known as Il Cerano, that depicts a beautiful but melancholy young woman with a large ulcerating lump in the right upper, outer quadrant of her right breast.

Il Cerano, *The Madonna Delivers Milan from the Plague*, Santa Maria della Grazia, Milan, Italy. Photo: Mauro Ranzani. Photo Credit: Scala/Art Resource, NY.

Though the title uses the term *plague*, the lesion painted resembles more of breast cancer than it does of the bubo of the plague. Bubonic plague is a bacterial illness. It attacks the lymph system of our bodies and often causes large, redden, and tender swelling of the lymph nodes, known as buboes. The appearance of such a bubo would be in the armpit or axilla of the person not as it appears in the fresco in the Madonna's breast. Was this a mistake? Or was it something more? Could Il Cerano be highlighting an occurrence that every woman had heard of and might have encountered in their lifetime? Could this breast cancer?

Though tens of thousands would die in Milan from the plague during the early seventeenth century, breast cancer was surely a known resident in many of the woman during that time. What a fitting example of a miraculous intervention! The lesion shown here and agreed upon by an astute group of cancer doctors was indeed breast cancer. The divine deliverance was more of a prayer than a reality. Though the plague would decline in its fury over the next few decades, the torment of breast cancer would be with the Milan population to this day. What Il Cerano was depicting was perhaps more a hope rather than the reality women were facing. If the Madonna could save Milan from the plague, why couldn't she save Milan from breast cancer?

The use of religious allegory and devotion is nothing new to the story of how women throughout Europe coped with this horrid disease. We see here a modification of what the Egyptians, Greeks, and Romans used to deal with this illness. But now, with the advent of Christianity, a whole new world of appellations and beliefs come into place. Stories of saints and the interaction of angels carry the message of hope. Belief in virtue and the resolute faith in their religion will keep a woman safe and sound not only against this disease but even against its therapy, mastectomy. Though no one was sure how to treat this disease, there was a ray of hope that miraculously, faithfully, a woman could possibly survive against all odds.

There is one further image that we would like to share with you. At that same confer-

ence, we were shown the painting of *The Miracle of San Carlo Borromeo* by Dr. Michael Baum, professor emeritus of Surgery at the University College of London.

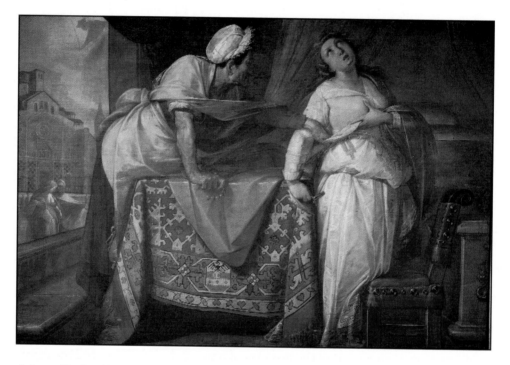

Il Cerano, Miracles of St. Charles: Miracle of Beatrix Antonio Crespi. Margherita della Guardia Veneta, Museo del Duomo, Milan, Italy. Photo Credit: Photoservice Electa Mondadori/Art Resource, NY.

To use Dr. Baum's own words in the email that he sent to us: "It looks like a cyst to me. I cure them all the time with my miraculous syringe and needle." Miraculous indeed, since the syringe and needle had not yet been invented at the time of this painting. Anything that

would make such a mass (cyst) disappear was indeed a miraculous event. Cancer though known to be a killer, was hard to differentiate from other maladies that affected the same organ such as cysts. But it is the way that all of these diseases of the breasts are reflected that is the real answer. There was no known cure. Divine interventions via a miracle were the only solution. Interestingly, though breast cancer is truly a disease of predominately older woman, the women described by these artists are all young. The reflection here is that no one is spared this horror. Youth is not a deterrent. Everyone could be a victim. Pray for us!

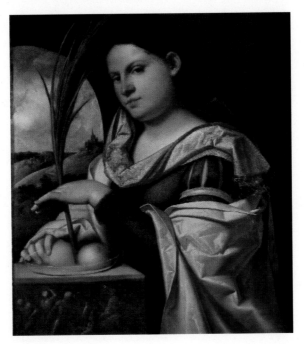

Giovanni Cariani, *Saint Agatha*, National Gallery, Edinburgh, Scotland. Photo Courtesy National Galleries of Scotland.

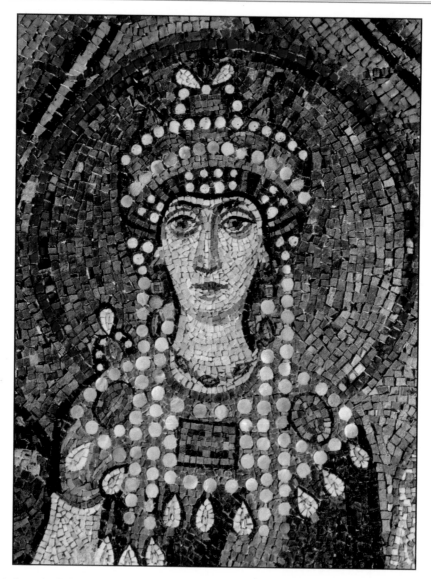

Theodora's Court - detail. Bust of Theodora, mosaic, San Vitale, Ravenna, Italy. Photo Credit: Scala/Art Resource, NY.

CHAPTER FOUR: FROM SEXUAL GODDESS TO PURITANICAL EMPRESS

"Often, even in the theater, in sight of all people, she removed her costume and stood nude in their midst, except for a girdle about her groin; not that she was abashed at revealing that, too, to the audience . . ."

Procopius' *Secret History* concerning Theodora's thespian accomplishments.

The story of Empress Theodora is a story of sensuality, beauty, lust, and power. It is also a story concerning breast cancer in the sixth century. What we know of Theodora's early years comes primarily from the work of Procopius. He was the legal secretary to Belisarius, Justinian's chief military commander, and kept a journal describing his observations of the court of Justinian as well as gossip. To some, his accounts of both the Emperor Justinian and Empress Theodora mirror his total disillusionment with their reign. But one thing is for certain, he pulled no punches when it came to Theodora's past and her activities in the hippodrome. The lurid details of Theodora's early life find corroboration of sorts in

an unexpected source. The Syriac historian John of Amida, better known as John of Ephesus, for he became the Monophysite bishop of that city, refers to Theodora almost casually as "Theodora from the brothel" (ek tou porneiou).[1]

What we know for certain is that Theodora was born to a poor family either on the island of Crete or perhaps, even Syria. Her father was a bear trainer of the hippodrome blue faction in Constantinople. As soon as she was old enough, Theodora was put on stage by her mother. This was practically synonymous with being a prostitute in the sixth century, an entertainer. There are many stories concerning Theodora's on and off stage antics. One that won the hearts of many a nobleman, including Justinian, was her portrayal of Leda and the Swan. According to Procopius, she would strip off her clothes down to a ribbon about her groin. She would lie on her back while attendants spread barley on her groin. Trained geese would then peck up the barley with their beaks. Her fame as a sexual acrobat as well as her infamy as a prostitute was known throughout Constantinople, as Procopius so explicitly writes:

1. John of Ephesus, (*PO* 17, i, 188–89)

"She was the kind of comedienne who delights the audience by letting herself be cuffed and slapped on the cheeks, and makes them guffaw by raising her skirts to reveal to the spectators those feminine secrets here and there which custom veils from the eyes of the opposite sex. With pretended laziness she mocked her lovers, and coquettishly adopting ever new ways of embracing, was able to keep in a constant turmoil the hearts of the sophisticated. And she did not wait to be asked by anyone she met, but on the contrary, with inviting jests and a comic flaunting of her skirts herself tempted all men who passed by, especially those who were adolescent. On the field of pleasure she was never defeated. Often she would go picnicking with ten young men or more, in the flower of their strength and virility, and dallied with them all, the whole night through. When they wearied of the sport, she would approach their servants, perhaps thirty in number, and fight a duel with each of these; and even thus found no allayment of her craving. Once, visiting the house of an illustrious gentleman, they say she mounted the projecting corner of her dining couch, pulled up the front of her dress, without a blush, and thus carelessly showed her wantonness. And though she flung wide three gates to the ambassadors of Cupid, she lamented that nature had not similarly unlocked the straits of her bosom, that she might there have contrived a further welcome to his emissaries."[2]

2. Procopius: *Secret History,* translated by Richard Atwater, (Chicago: P. Covici, 1927; New York: Covici Friede, 1927), reprinted, Ann Arbor, MI: University of Michigan Press, 1961.

Much of her young life was spent travelling, spending time in North Africa and Egypt. She gave up her wild life eventually to become a wool spinner in a house near the palace and apparently caught Emperor Justinian's eye.

The Byzantine Empire spanned an enormous amount of time, beginning in 330 AD when Constantine named Constantinople the capital up until 1453 when the empire fell to the Ottoman Turks. The territory expanded and contracted through time but mainly consisted of the Balkan Peninsula and Asia Minor. Its greatest emperor was Justinian (527–565 AD) who had literally lost his head and heart to Theodora. He would set her up as his mistress. When, in 527, Empress Euphemia died, two days later he married Theodora and made her his queen, repealing a law that had stated the Emperor could not marry actresses. For any politician, no less an Emperor, wouldn't this be a secret worth hiding? For Theodora, her past was the lesser secret she felt the need to hide. Something much more ominous, so much more sinister and evil was lurking within her, something that she would take to the grave rather than expose.

Theodora ruled at the right hand of Justinian and was often toted as one of the most powerful and intellectual women the Byzantine Empire had ever seen. The squelching of a 532 riot is in fact credited to a powerful speech Theodora gave, convincing her husband and other leaders not to flee the palace, but rather to remain as rulers should. She not only gave her husband strength, but tried to also better the situation of women throughout the Byzan-

tine Empire by passing laws that closed brothels, made prostitution illegal, and gave women more property rights, among other things; quite a change from her younger days. In 528 a law stated rapists and kidnappers of women, both free-women and female slaves, should receive capital punishment. A 534 law made it illegal to force any woman on the theatrical stage without their consent, regardless if said woman was free or a slave. In 535, laws were passed against those who force underage girls into prostitution. A 537 law allowed actresses to renounce their occupation at will. Theodora's involvement with such judicial matters and women's rights was quite possibly a strong reaction to her past.

Twenty years after marrying Justinian, at the height of her power, Theodora discovered she had cancer, most likely breast cancer. She enlisted the help of Aetius of Amida who was the physician to Justinian. Aetius was a freed Egyptian slave who studied in Alexandria. His fame as a diagnostician and healer was well known throughout the Byzantine Empire. He was also one of the first to describe the surgical removal of a tumor from the breast. The sixteen books of his *Tetrabiblus,* one hundred and eleven chapters of it, were dedicated to obstetrics and gynecology. He described vividly what fifteen hundred years later would be championed by Halsted. Namely, to remove all of the diseased tissue, otherwise the cancer would return. Aetius referred to Archigenes and Leonides stating that tumors were more frequent in women and quite rare in men, even though at this time cancer had been recognized in the male breast. In detail he described two forms, those with ulcers and those with-

out, describing the enlargement of veins with redness on what appears to be soft, but is really very hard tissue. His description of breast cancer talks of a growth that is deeper and deeper and cannot be stopped until it "emits a secretion worse than the poison of wild beasts." He concludes that this form of cancer is made worse by drugs. His methods were without the help of anesthesia or infection control. His technique was to lie the patient down and excise all the diseased tissue that could be seen. In his primitive ways, he tried to establish the concept of trying to achieve adequate margins between that of cancerous tissue and normal tissue. He would use a red-hot iron to control bleeding. Cautery was believed to destroy the remains of the diseased tissue- a tortuous, painful, and often, futile exercise that was more feared than the disease itself.

For a person such as Theodora, the choice was quite clear. She would refuse the surgery and not be disfigured. She elected to keep control of her life in the best way that she could imagine. This was her secret, one which she shared with Justinian and Aetius. Interestingly, Procopius describes this part of her life as well, ". . . she treats her body with such great care, more than is needed. She enters the bath early and after bathing, goes directly to breakfast. Then sleep lays hold on her for long stretches." Theodora died on June 28th, 548, 17 years before her husband, her body buried in Constantinople.

What do we really know of Theodora? What piece of art work, what statue or mosaic testifies to this once darling of the hippodrome whose body was there for all to see and for an

Emperor to dream about? Theodora and Justinian upheld all the formalities of ceremony and dress of the empire. Theodora in particular was punctilious about court ceremonial. Procopius laments that Justinian and Theodora made all senators, including patricians, prostrate themselves before them whenever they entered their presence, and made it clear that their relations with the civil militia were those of masters and slaves.[3] The images of the court in Ravenna are obvious displays of such formality.

3. Procopius, Anek. 30.23–6.

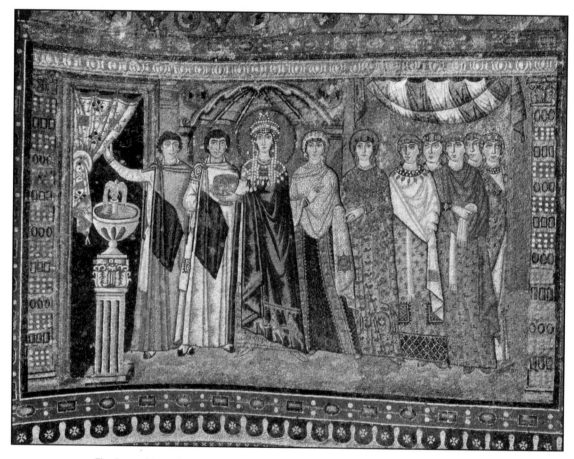

Theodora and her retinue, mosaic, San Vitale, Ravenna, Italy. Photo Credit: Scala/Art Resource, NY.

The Basilica of San Vitale is octagon in shape and one of the best examples of Byzantine architecture and decoration that can be seen outside of Constantinople. The building may have been funded by a Greek banker, Iulianus Argentarius, or quite possibly by Justinian

himself as political propaganda. The central part of the church is surrounded by two ambulatories or walkways, one reserved exclusively for women. The entire interior is decorated with shimmering, glowing mosaics, a vision that would have been enhanced by the candlelight used to illuminate the basilica. Some decorations are vegetal, while others are intricate geometric patterns. In the lunettes there are Old Testament stories depicted such as the Sacrifice of Abraham or Moses and the Burning Bush. The Four Evangelists can be seen on side walls along with their symbols of the angel, lion, bull, and eagle. The mosaics are not only vibrant with gold, but also alive in feeling. The trees and leaves shake in the breeze and the birds and animals are about to run or fly off, all of this depicted on a flat wall. The artistic ability of the master mosaic craftsmen is superior to none. The stories come alive and almost dance off the wall. On the triumphal arch figures from the New Testament, including Jesus and the Twelve Apostles, are depicted. It is on the side walls of the apse however that the most famous images of the Basilica can be seen. On the left is Justinian, in regal garb, and his retinue of court officials, guards, and Bishop Maximian. The Emperor has soldiers on one side and religious leaders on the other, demonstrating that he is both in charge of religion and state. In fact, if you look at the placement of the figures' feet, you will notice they overlap, with Justinian's feet being the front, hence the most important. Opposite we find a mosaic panel of Theodora.

In the Basilica of San Vitale the Empress Theodora is decked out in her full length purple

regal robe known as a chlamys, accompanied by her retinue. The border of her robe is decorated with the Three Magi bearing gifts, as she does in the mosaic, holding a Eucharistic chalice. She is bejeweled and elegant, only the nape of her neck and facial skin visible, an elaborate collar covering her shoulders and chest. While Theodora's jewels weigh heavy, so must have her heart, for hidden beneath her regal robes stood the presence of her killer. Devouring her and consuming her from within, the secret of Theodora was that of silence. It was an ordeal that needed to be covered up and never disclosed, hiding beneath the formality of protocol, her sumptuous robes. The art that would forever describe this queen would mock the existence of her cancer. For a disease such as this that could not be cured, this was the only way to make it disappear.

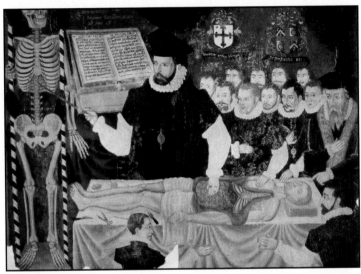

The Anatomy Lesson given by John Banister (1533-1610) at the Barber Surgeons Hall in 1548.
Fontispice of 'De re anatonomica' by Matteo Realdo Colombo (Renaldus Columbus) (1516-1559) ca. 1580.

Elizabethan England was a time engulfed in mystery, intrigue, conspiracy, royal politics, and disease. The words of Shakespeare's *Macbeth* are a perfect backdrop to the atmosphere that enshrouded the English isles at this time. London, in particular, was a city in which the curses of the plague were ever present. Lack of sanitation, poor water supply, and the crossroads of commerce made the perfect storm for diseases such as the bubonic plaque and typhoid fever to destroy large numbers of the population. But with everything

Elizabethan, there was always a side story behind each plot. Diseases including breast cancer were still full of mystical origins and therapy was, if any, confined to the most rudimentary procedures and more often nonexistent.

Medicine in Elizabethan times was full of far out potions and crazy rituals. All in all, medicine remained mostly medieval in Elizabethan times. Many physicians based their philosophies on the teachings of Aristotle and Hippocrates. These beliefs were widely accepted during the medieval period. However, the emphasis on magic and astrology diminished in Elizabethan times. Yet, some physicians still believed that if the planets were out of line, an individual would get sick, according to his or her own sign. It is interesting that the different types of physicians had their own type of hierarchy. Doctors that dealt with diseases such as the plague, typhoid, or breast cancer belonged to the College of Physicians. Surgeons had a rather diminished status and were actually considered to be a part of the Union of Barbers. Barbers actually fit into this hierarchy since surgeons and barbers alike performed modalities such as bloodletting. Their status was below that of surgeons. The lowest level in Elizabethan medicine belonged to the apothecaries who became known as the physician's cooks, likened to grocers, simply pulling ingredients off their shelves.

The sight of a physician attending the sick was enough to evoke fear and anxiety by their mere appearance. The physician would wear a long robe down to his ankles. He would have

on long boots and thick leather gloves to his elbows. He wore a mask with a long beak filled with bergamot oil.

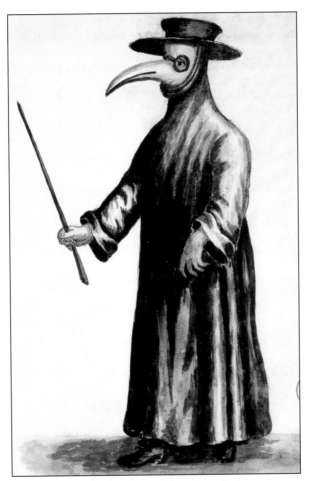

Jan the Younger Grevenbroeck, *Masked doctor during the plague in Venice,* from the Grevenbroeck manuscript, 17th century, Museum Correr, Venice, Italy. Photo Credit: Erich Lessing/Art Resource, NY.

Amulets of dried blood and ground up toads were worn around his waist. This was a time of the plague in which death, in most cases, was swift and the mode of transmission was totally unknown. The concept that the plague was being transmitted by the bite of a flea that carried the bacteria Yersinia Pestis was still centuries away. Like most diseases, the concept of bad humors still pervaded the thoughts of the medical community. The humors were bodily fluids all thought to originate in the liver. Blood, phlegm, yellow bile, and black bile were the four humors. Supposedly the level of humors in the body characterized the personality. If a person had more blood in his body, he was characterized as being very passionate. With abundance of phlegm, the personality was characterized as being cowardly and lacking in intellectual ability. Yellow bile meant that the person had a choleric personality or vengeful and easily angered. Black bile meant that the person was melancholy or excessively brooding. Through the centuries, the concept of humors, originally promoted by Hippocrates, had some strange modifications. In 200 AD, Galen, living six centuries after Hippocrates, suggested that *black bile* coagulating in the breast caused cancer. Monthly clearing of this black bile would be accomplished by menstrual periods. Obviously, when a woman no longer had her periods, she would not be cleansed. This gave substance to Galen's followers of why post-menopausal women had more breast cancers. Other rather bizarre ideas about the origins of breast cancer began to spread from continental Europe. Ambrose Pare (1520–1590), a French surgeon and official royal doctor, advised women not to gossip as a

way of preventing the disease. He recommended that on an ulcerative breast cancer the internal, still warm, organs of animals be applied. To his credit, Pare did recognize that swollen axillary lymph nodes were indeed a bad thing. He also advocated the use of ligating the blood vessels rather than using a red-hot iron to stop the bleeding after a mastectomy. In Germany, Wilhelm Fabry (1560–1634), author of 20 surgical books and the father of German surgery, thought that the cause of breast cancer was due to milk curdling in the breast. He is reported to have done the first axillary dissection. Prior to his work, mastectomy was truly just a guillotine procedure in which bleeding was controlled by cauterization by hot iron pokers. In the mid 1500's Gabriele Falloppio (1523–1562) working at the University of Padua modified Galen's theory. He came up with the concept that non-natural bile was a combustion product of different humors. According to Falloppio, cancers consisted of a blend of blood and burnt black bile humors. The degree of the malignancy depended on just how much blood versus burnt black bile the cancer possessed. In tumors that were inflammatory, that is, involved the skin and displayed redness and open ulcerations, these would have had a high degree of burnt black bile as compared to blood. No doubt, this led to Falloppio's belief in bloodletting in order to remove the black bile.

It is no wonder that Elizabethans had a great deal of problems concerning illness, especially something as foreboding as breast cancer. It was truly a Shakespearian plot. Elizabethan doctors were walking around in costumes fit for a Greenwich Village Halloween

parade. People were dropping dead like flies (or should I say fleas) by the tens of thousands from something called the plague that no one understood. The theories about breast cancer ranged from bad humors to combustible humors to curdled milk to too much gossip. Its therapy still consisted of a guillotine-like mastectomy, which also worked well as a way of torture and of course to bloodletting to get the bad humors out.

With all that said, we can talk about one of the most famous cases of breast cancer that supposedly happened in Elizabethan England. I say supposedly because intrigue and sub-plots ruled the world at this time. Breast cancer was a malady of frightful consequences and of eventual death. No one just came out and declared that they had it. Much illusion and se-crecy greeted it. Amy Robsart, who as some art historians have commented, was better known for her death rather than for her life. She was born in Norfolk to Sir John Robsart and Elizabeth Scott. They were very wealthy and neighbors of the Dudley family. John Dud-ley was the first Duke of Northumberland during the reign of Edward VI and had two sons. Robert who would marry Amy Robsart, at the time eighteen, and a younger son, Guilford, who would marry Lady Jane Grey who would become the Queen of England for nine days. After many ill-fated attempts to put Lady Jane Grey on the throne, Robert was imprisoned. Eventually he was let out and served in the army fighting in France. When Elizabeth suc-ceeded to the throne in 1558, a new chapter of the life of Amy and John began to unfold. Dudley began to spend most of his time in the court of the new queen. It was believed that he

was her lover. He kept Amy far away from the court as to not remind the queen that one of her favorites was indeed a married man. In 1560, Dudley resided in the manor house of Cumnor Place. The house was owned by friends of Dudley who may have also lived there. According to legend, Amy Robsart was kept as a sort of a prisoner there.

Amy Robsart's life inspired Sir Walter Scott to write the historical romance *Kenilworth* in 1821 and there has been much conjecture about whether her demise was accident, suicide, or murder. While the life of Amy and John is shrouded in secrecy and lies, there is one thing that is known for certain about Amy Robsart prior to her death. She was claimed, and rumors had been circulating around the court from as early as 1559, to have suffered from an aliment of her chest which some historians believe to be breast cancer. They have gone so far as to claim that it might have even spread to her bones and many commented on Amy's unstable state of mind. So it is here that we weave our Shakespearean plot. We have a young woman who seemingly has breast cancer that might have spread to her bones. We have her unfaithful husband, now the Earl of Leicester, with the queen as his possible lover. The heroine is kept away from the queen and possibly a prisoner in her own home. What diabolical ending could the great bard come up with? Perhaps it could be the curious finding of the young scorned woman lying dead at the bottom of her stairs? Precisely!

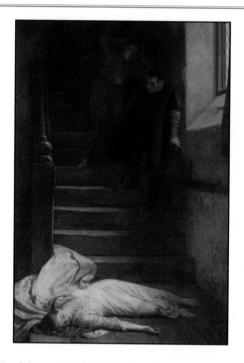

William F. Yeames, *Death of Amy Robsart*, exhibited 1877, Tate Gallery, London. Photo Credit: Tate, London/Art Resource, NY.

The date of her death is well documented. It was Sunday, September 8, 1560. It was the day of "Our Lady's Fair" in Abingdon. According to legend, Amy gave the servants the day off to attend the fair even when some resisted. She was left alone in the house with her long-time companion Mrs. Oddingsell as well as a Mrs. Owens, the mother of the former owner of the house, and Mrs. Foster, the wife of the current owner. When the rest of the servants returned from the fair, they found Amy at the foot of the shallow stair that led from her bedroom. Her neck was broken, although the headdress she wore was still perfectly in place.

The news of her death was conveyed to Dudley and the Queen at the same time. Seemingly, Dudley sent one of his men to check out the circumstances of his wife's death. He did not attend her funeral.

Like all good Shakespearean stories we need some subplots. Could Dudley have arranged his wife's death so that he could get closer to the Queen and even possibly marry her? Could the Queen have ordered Amy's death herself? According to one account, even prior to Amy's death, the Queen supposedly told the Spanish ambassador that Dudley's wife was near death. Could this have been a plot by William Cecil, the Queen's secretary, who had fallen out of favor with the Queen with Dudley's rising popularity? Cecil would know that with all the controversy that surrounded Amy's death that it would be impossible for Dudley to marry the Queen. Could Amy's bones have been weakened so greatly that she fell down the stairs? Could this have been a suicide by Amy? It is said that Amy would "pray to God to deliver her from this desperation." Was this desperation that of an unfaithful husband or that of an unyielding disease that was destroying her from within? We will never know.

The complexity and the drama that surrounds the Amy Rosbart death exemplify many of the feelings and circumstances experienced by Elizabethan woman. Not that all had unfaithful husbands having an affair with the Queen. But rather reflecting the times when diseases such as breast cancer were indeed mysterious, life threatening aliments to which there

were no real answers. It was their own plague. It had been a plague before the fifteenth century and continued to be so. It was associated with being a prisoner not just within one's house but also within one's own body. It caused a death that was scoundrelus and caused the patient often to live a life that was removed from those they loved. In many ways, the trials and tribulations of a patient afflicted with breast cancer had more subplots and backdrops than any Shakespearean play. The fates of these patients were often prayers of deliverance from the desperation of this illness.

So how could an artist reflect this complex set of emotions and circumstances? How could they deliver that wide set of beliefs and experiences that this one episode of breast cancer in Amy Robsart portrayed? The answer comes from the painting by the Victorian artist William Yeames, *The Death of Amy Robsart.* We see the crumpled, alabaster figure of a young woman sprawled out beneath the stairs. There is no one running to her side. Those walking down the stairs do so slowly, almost as if they were checking on her ill fate, no display of horror or sorrow. There is stark loneliness about her. Her pallid skin blends into her clothes and she is bathed in light, finally reaching a peaceful end. How did she get there? What were the circumstances that led her to this end? We can only reflect on her image. The rest is a mystery for now. This is the scene not just of Amy's disease and death but a reflection of what awaits any woman who has her aliment, lurking at the bottom of their stairs.

CHAPTER SIX: A MARBLE MONSTROSITY

In 1999, an American medical oncologist named James Stark was visiting Florence on a trip with his wife. They stopped beside the sculpture of *Night* by Michelangelo in the Church of San Lorenzo. On the left breast of the reclining woman, there was something very noticeable to this medical oncologist. "There is a bulge on the top of the breast, a swelling in the nipple and a puckering to the side of the nipple. I've been doing this my whole life and just stood there and said, 'That's breast cancer.'" Two years later, along with art historian Jonathan Nelson, they published an article in the *New England Journal of Medicine* describing in detail their diagnosis. The bulge in the breast beside the nipple, the swollen nature of the nipple and areola, the area of skin retraction were all tell-tale signs of a locally advanced tumor of this breast. Even the texture of the stone gives rise to the feeling and description of the *peau d'orange,* the orange peel image, the swollen lymphatics of the skin encased by the creeping tumor. Could this possibly be? Why would Michelangelo, in full sight, place breast cancer in the breast of this model? Surely, this had to be a mistake. Perhaps, Michelangelo was in a rush to finish his project? Perhaps, Michelangelo felt un-

comfortable describing the female anatomy? Or was it something more? Was it that the artist was rendering an image, a reflection so precise, so direct as to take our direction not just to this altered rendering but also to a higher place? Why pick the female on the right, the *Night* sculpture? Was it her death that drew Michelangelo near?

The Church of San Lorenzo was built in Florence between 1419 and 1469 on the site of two previous churches. Built catty-corner to the back of the Medici Palace, this church was known as the Medici Church, its building and decoration grossly funded by the family. It is only fitting then that the two sacristies and crypt be the burial ground of most Medici family members. While there could be much said about Brunelleschi's architecture in the church and the illustrious Medici buried in the Old Sacristy, it is the New Sacristy of San Lorenzo that is of interest to us here, begun about 100 years later. Michelangelo was commissioned to execute the design as well as the sculptures of the New Sacristy, which is essentially a burial chamber for the Dukes Lorenzo and Giuliano de Medici with grand tombs; and in utter simplicity at the base of the statues of patron saints Cosmas and Damian, flanking the Madonna and Child, the bodies of Lorenzo the Magnificent and his brother Giuliano.

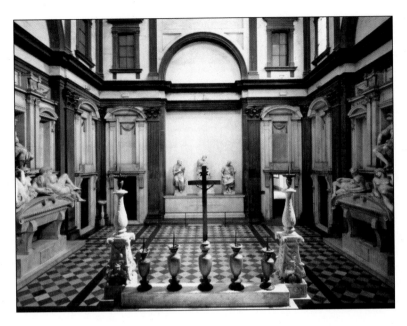

View of the *interior of the New Sacristy*, Basilica of San Lorenzo, Florence, Italy, designed by Michelangelo Buonarroti (1475-1564).

Photo Credit: Alinari/Art Resource, NY.

The architectural decorations in the New Sacristy exemplify Michelangelo's prolific use of the most *au current* thoughts on architecture. Instead of following the clearly defined classical uses of architectural elements as often praised in the High Renaissance, in essence emulating antiquity, Michelangelo pushes the envelope. The architectural elements are crowded; they appear to almost want to burst out of the square structure that is the New Sacristy. He is avant-garde. After having toyed with the idea of placing the burial tombs as

free-standing structures in the center of the room, Michelangelo decided on a different layout with the tombs opposite each other on either side. Just as the architectural elements create a sense of unease, so do the sculptures on the tombs. At eye level, sarcophagi with curved lids defined by volutes support a pair of figures, male and female. The subject matter may come from Dante's *Convivio* in which Dante describes life as being an arc that rises and falls and has four segments: the four ages of man, the four seasons, the four times of day. The figures appear to be too big, almost sliding off the lid of each tomb. Ichnographically, the personifications found in each sculpture are perfect subject matter for a burial chamber. The figures of Dawn, Dusk, Night, and Day lounge on top of the sarcophagi, signifying the beginning and end of an extremely terrestrial unit of time—the day, our twenty-four hours. Portrait sculptures of Dukes Lorenzo and Giuliano above the tombs appear as if they were still alive, although all figures in the chapel have been carved without pupils as if in attempt to close their eyes to the passing of time. Giuliano is active, while Lorenzo appears to be more contemplative. Night and Day under Giuliano seem more appropriate for his alert pose, while the slower passing of Dawn and Dusk under Lorenzo capture his more thoughtful rendering.

The heavy sculptural feel of the ground floor of the chapel becomes lighter and lighter up to the dome, where light streams in through the windows as one looks up, closer to God. This is in fact the message. On the bottom, our earthliness weighs us down, but after death

and as we get closer to God, everything is more ethereal. The structure is a meditation on the shortness of life, the inevitability of death, and the Christian hope for Resurrection.

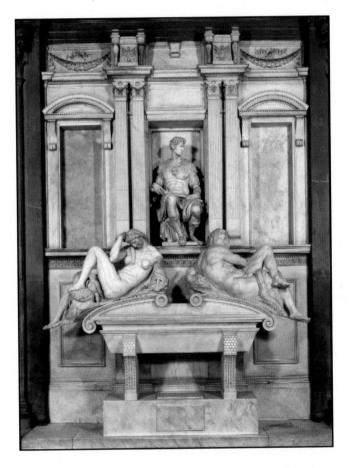

Michelangelo Buonarroti, *Tomb of Giuliano de Medici*, Duc de Nemours (1479-1516). 1519-1534. Post-Cleaning. Basilica of San Lorenzo, Florence, Italy. Photo Credit: Scala/Art Resource, NY.

Of all the figures in the New Sacristy, only the figure of Night has iconographic attributes, symbols of night: a crescent moon, an owl, a mask, and a bunch of poppies. The poppies and mask represent sleep and death, which were considered the children of Night. Condivi, a painter and writer in sixteenth century Italy says that another symbol was planned for one of these figures: a mouse, ". . . because this little animal gnaws and consumes, just as time devours all things. Michelangelo left a piece of marble on the work for it, which he did not carve . . ." The general significance of Night and the times of day seem to be clarified by this mouse. Man's mortal life succumbs to the gnawing of time. When Michelangelo had finished the figure of Night, a Florentine poet named Strozzi wrote a poem in honor of the statue, with a pun on the name Michelangelo:

The Night you see sleeping in sweet repose

Was carved in stone by an angel.

Because she sleeps, she had life.

If you do not believe this, touch her and

She will speak.

Michelangelo, also a poet, wrote a poem in response:

Sleep is precious, more precious to be stone

When evil and shame are abroad;

It is a blessing not to see, not to hear.

Pray, do not disturb me. Speak softly!

Michelangelo was a rather personally religious person. His art, as many of his contemporaries, was a close study of classical art and ideals. His genius is the spark that has ignited many theories, much research and volumes of the written word. Michelangelo's adoration of the human form, in particular the male form, can easily be detected in his many works, from *David*'s perfect body to the contorted muscles of his *Slaves*. Greater attention paid to the male form, as well as his rather bulky females, best seen in the *Sibyls* on the Sistine Ceiling, has spawned theories on Michelangelo's sexual orientation as well as thoughts on the male workshop employees of the artist used as models for female and male figures alike. While it is often thought that his female figures are male bodies with breasts simply added on, this limited view sharply curtails Michelangelo's artistic genius and is a superficial explanation of an artistic process that we are today only privy to in limited knowledge.

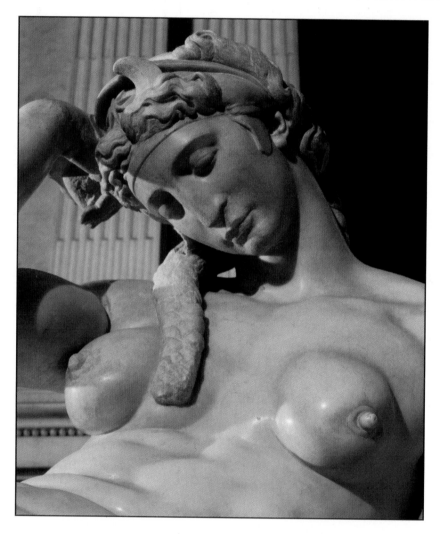

Michelangelo Buonarroti, detail of *Night* from the tomb of Giuliano de Medici, Duc de Nemours
(1479-1516). 1519-1534. Basilica of San Lorenzo, Florence, Italy. Photo Credit: Erich Lessing/Art Resource, NY.

The study of human anatomy in the Renaissance was an integral part of any artists training. Artists' workshops studied the body. Sketch books from fourteenth and fifteenthcentury Italy are filled with renderings of hands, feet, craned necks and other body parts and master artists prided themselves on their perfect depictions of the human form. Poets, such as Strozzi, praised the life like qualities of the figure of *Night*, so close to life that if the visitor woke her with a nudge, she would speak. Are we to believe that Michelangelo, if he wished to, could not create the most sensual female form?

Following the temporal theme in the sculptures of the New Sacristy, Dawn and Night embody two different times in a woman's life. Dawn, rousing herself from a deep sleep, is a virgin with high firm breast and a symbolic belt. Night, whose abdomen and breast have passed the trials of childbirth, is a mother. An image that is so typical for the majority of breast cancer patients. This is a disease usually for those past their childbearing years—for breasts that have had enough of a lifetime of estrogen to foster this disease. Michelangelo gave us a very precise example of those that might experience this ravage. Only the statue of the Virgin Mary in the room manages to embody both states miraculously, pressing the Christ child to her breast. It is the figure of Night that is our focus here. She is the only figure in the chapel given attributes, such as the moon. Her breasts are used and spent with lactation. The unattractive portrayal or her breasts can not simply be the supposed lack on

Michelangelo's part of sensual feelings towards the female form. She is the older of the female figures, and if we look closer, there is more than just consumed flesh and age.

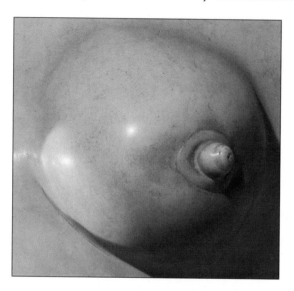

Michelangelo Buonarroti, close up of breast in Night from the tomb of Giuliano de Medici, Duc de Nemours (1479-1516). 1519-1534. Basilica of San Lorenzo, Florence, Italy. Photo Credit: Alinari/Art Resource, NY.

Her left breast appears to be afflicted with signs of malignancy, signs that are glaring clear to oncologists visiting the New Sacristy. Many have pondered the erroneous anatomical portrayal of the female figure of Night. How could a genius such as Michelangelo have made such a mistake? Or was it? Wasn't his workshop paying attention? Almost every tourist visiting the New Sacristy in San Lorenzo has picked up on the ugliness of Night's breasts, but a trained oncologist could easily point out and diagnose cancer from the puck-

ering of the skin, the retraction of the nipple, and fullness of the axilla from enlarged lymph nodes. Dr. Stark could have been looking at a number of his own patients when he gazed upon the left breast of the Night. Who did Michelangelo know that was suffering from this horrible disease? How many times did he see these same glaring reflections on the bodies of those he sketched from the local morgue?

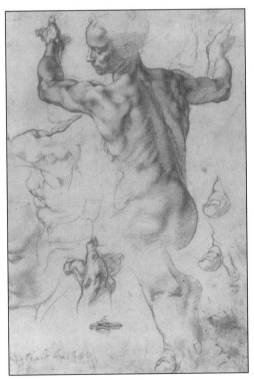

Michelangelo Buonarroti , Studies for the Libyan Sibyl (recto). 1508-1512. Red chalk (recto), 11-3/8 x 8-7/16 in. (28.9 x 21.4 cm). Puchase, Joseph Pulitzer Bequest, 1924 (24.197.2). Metropolitan Museum of Art. Photo credit: Image copyright © The Metropolitan Museum of Art/Art Resource, NY.

Much discussion has transpired over Michelangelo's thoughts on the superiority of the male body. Many have gone as far as to say that he simply made a male body and stuck female breasts on it, but possibly a female breast with cancer symptoms? Can we possibly dilute the artistic genius of Michelangelo in such a manner? Can it be chalked up to a pupil having possibly finished off the statue? Does breast cancer in Night ring true to the entire meaning of the New Sacristy, echoing the inevitability of death? Look at the expression on the face of this consumed lady. There is no fright. There is no pain. Rather the expression is one of acceptance. It is an expression of knowing one's fate and hope of a better life. The wisdom here is that breast cancer is only part of a transience that will be overshadowed by an eternal life. The fate of any woman with this disease has to be accepted as any other aspect of the stages of life. The only remedy was in the belief that this too would pass. Michelangelo for all his brilliance could not render a cure. His art could only give credence to the belief in the hereafter. The artist would not only describe this horrid disease but give testimony to its ultimate weakness —the human spirit.

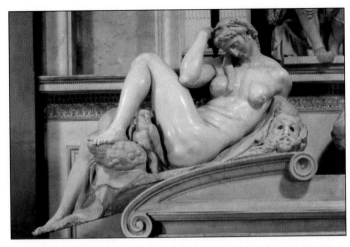

Michelangelo Buonarroti, *Night* from New Sacristy, Basilica of San Lorenzo, Florence, Italy. Photo Credit: Scala/Art Resource, NY.

Michelangelo was a genius. This point, very few would debate. From a young age, with the study the *Belvedere Torso,* an ancient sculpture, as well as others, he appreciated the complexities of the human form, the ideal beauty it represents. In sculpture he captures the ethos of his figures. His *Bacchus* in the Bargello in Florence truly is inebriated. *David* (The Accademia, Florence) the young warrior looks worried and at the same time resilient going out to fight the giant Goliath. The Madonna in the *Pieta* (St. Peter's Basilica, Rome) clearly suffers holding her dead son, but with an inner peace that alludes to the higher mission. The figures in the New Sacristy, through their positions and facial expression, convey the time of days they represent. Michelangelo is on the cusp of artistic ideas and creativity. One of the

first artists to take the High Renaissance ideals of balance and perfection, slowly distorting them, twisting, pushing to the limits. His *Slaves* in the Accademia in Florence contorted in their struggle, the Old Testament figures on the Sistine Ceiling, reaching, stretching and flexing in the spandrels. Michelangelo's innovative use of architectural elements stun in the Laurentian Library, where the stairs seem to flow down like lava and the walls have come alive, bursting with kneeling columns and tapered pilasters. The soft and gentle Madonna reliefs in the Bargello in Florence are created with extreme attention to the technical process of sculpting. All the above are but a few examples of Michelangelo's genius. His physical and technical ability to produce, his insight into human emotion, his working on the forefront of artistic invention and his great knowledge of classical ideals all point to a man who could have created anything, even the most perfect female form and breasts. Reflections of any disease are not confined just to flesh and blood. A true artist, Michelangelo being one of the best, could also reveal the soul of those afflicted. For as Strozzi stated, "If you don't believe this, touch her and she will speak."

CHAPTER SEVEN: IN PLAIN SIGHT

In 1967, an Italian physician named T.C. Greco was vacationing in Paris. He visited the Lourve and stopped before Rembrandt's painting of *Bathsheba's Bath*. Greco was a surgeon and with this eye he viewed the painting from an entirely new perspective, that of a doctor. There on the left breast extending into the left axillary area was a lump. The skin was pitted and had the texture of what is described in the medical literature as *peau d'orange* or the texture of an orange peel. For a surgeon or for any clinician that had experience with breast diseases, these signs were a clear indication that the person so described was suffering from breast cancer. Indeed, the reported model for this portrait, Hendrickje Stoffels, who was Rembrandt's mistress, would later be described as dying "after a long illness." The question as to why Rembrandt would put in plain sight such an abnormality and why until the latter part of the twentieth century would this elude art historians is a question into which we will delve more deeply.

The period of time that Rembrandt painted was known as the Baroque period. The philosophy behind this movement needs to be explained. Perhaps more importantly, with all of

the different portraits that Rembrandt painted, why did he choose *Bathsheba's Bath* to illustrate the illness in his beloved mistress? For now, let us walk down those same galleries in the Rijksmuseum and see for ourselves what has been hidden for all of these centuries in plain sight.

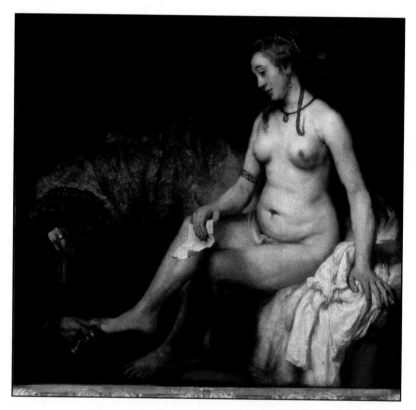

Rembrandt Harmensz van Rijn, *Bathsheba at her bath.* 1654, Louvre, Paris, France. Photo: Hervé Lewandowski.

Photo Credit: Réunion des Musées Nationaux/Art Resource, NY.

The word Baroque, which is derived from the Spanish *barroco* or the French *baroque* refers to a rough or irregular pearl. Critics of the period rather than those who actually practiced the art contrived the term. It was a time period roughly beginning in 1600 to the early part of the 18th century. Baroque was a term often used to describe the richness of color, the tumultuousness of movement and the contrasting use of light. The philosophy of the Baroque period whether it is in art, in literature or music has been thought to be a reflex from the Lutheran separation from the Catholic Church. Virtuosity along with realism and extreme attention for details became a common theme in Baroque art. Art became focused on the individual man, the everyday man. There was now a direct relationship between the artist and those that saw his art. This increased attention to the individual drew the observer deeper into the complex images, culminating in the individual depicted in the art itself. The heroes of the Baroque era are not just the gods and goddesses of mythology and the Bible. The heroes can be found in everyday persons. It is their virtuosity and often times their extreme earthliness that Baroque artists exemplify.

Though originally presented by Greco in 1967, there has been some debate over the last four decades as to whether or not the changes in the left breast and axillary area were intentionally made by Rembrandt or are they the "arbitrary effects of the painting's aging" as postulated by Jonathan Jones in 2001. However, upon closer review, Braithwaite and Shugg in the *Annales of the Royal College of Surgeons of England,* published that the " skin discol-

oration, distortion of symmetry with axillary fullness and *peau d'orange* can not be anything but a deliberate depiction of what he saw. They are the clinical signs of breast cancer." Both of these reviewers also noticed the expression on the face of the model portrayed as "enigmatically sad," a picture of "emotional endurance," "a woman weighed down yet full of fortitude," "she seems resigned to pain and aware of her own mortality." This is the demeanor that Rembrandt has placed on the face of his lover. Is this the face of a person knowing her fate? Is this a woman knowing that she has breast cancer? Rembrandt's *Bathsheba* is the reflection of what the artist saw in his own lover. It is the reflection of every woman!

But why did Rembrandt select *Bathsheba's Bath* to reflect this story? There are a multitude of themes, which he could have selected. The answer might just lie in the story of Bathsheba herself. The story comes from the Book of Samuel in the Old Testament. In this tale, King David saw a woman bathing. It was Bathsheba, the wife of Uriah the Hittite. King David committed adultery with Bathsheba and then arranged for her husband to be killed in battle. A messenger with a note was sent by King David to Bathsheba stating that Uriah was killed and for her to come to him. This is a story of a fate that cannot be repealed. The moral of the story is the precise reason why Rembrandt chose *Bathsheba's Bath* as the story in which to depict his lover with breast cancer. For Bathsheba, Hendrickje Stoffels, was being handed a note, which sealed her fate. Perhaps, this note told her of her diagnosis and ultimate demise. The look on her face is exactly what art critics have found in common. A

heroic woman, "weighed down but full of fortitude," making an everyday person a god or a goddess. The reflection that we see here, in plain sight, is well part of the Baroque philosophy portrayed in Rembrandt's art. It allows every woman to focus on the fate that has been handed to her. It glorifies the human spirit despite the known outcome. It boasts in the power of the individual.

The character that Hendrickje Stoffels portrayed had another thing in common with Bathsheba. Both were adulterers. The story of Bathsheba was that of a royal adultery. Hendrickje was accused of the same thing by the church. After Rembrandts first wife died, he had two housekeepers in succession to help raise his son Titus. The first one didn't last long, but the second, Hendrickje became his common-law wife and had children with him. She was actually brought up on charges of adultery and had to openly confess of having fornicated with Rembrandt. The casting of Stoffels in this role of Bathsheba was right on target for the melodrama that she was experiencing in her own life.

Rembrandt himself was indeed exposed to the medical ideas of the day concerning breast cancer. In 1632, he was appointed to paint the *Anatomy Lesson of Dr. Nicolas Tulp.*

Rembrandt Harmensz van Rijn, *The Anatomy Lesson of Dr. Nicolaes Tulp,* 1632. Mauritshuis Museum, The Hague, Netherlands. Photo Credit: Erich Lessing/Art Resource, NY.

Dr. Tulp was a very famous Dutch anatomist and surgeon who had promoted the idea that patients with cancer "died from autointoxication from their ulcerated cancers." Based on Dr. Tulp's anecdote that he treated both the mistress and her servant for breast cancer in the same household, he formulated the theory that would last for generations that breast cancer was a contagious disease. Years before the painting of *Bathsheba's Bath* and the pre-

sumed affliction of Stoffels, Rembrandt had already entered the murky world of breast cancer and was painting one of its pundits of the day.

Rembrandt's painting of *Bathsheba Bath* reflects all of these influences and focuses directly, in plain sight, on the patient. This is an elaborate painting full of metaphor and revelation, painted in the most precise detail and focusing directly on the subject. How this was never noticed until Dr. Greco pointed it out in his medical publication is something that we will never know. There is so much to digest in this painting. We look at Bathsheba's expression. We ask ourselves about the content of the note that she is holding. We think about the story of King David and Bathsheba. Then, if we look close enough at the details of this painting we find the distortion of her breast. We find the discoloration of her skin and we see the face of breast cancer head on.

Other painters of the Baroque period, most importantly Peter Paul Rubens also give us glimpses of breast cancer. A Ruben's painting conjures up in the mind, round, luscious, female bodies, pudgy cherubs and billowing rich folds of cloth. In the Prado Museum in Madrid, there are three paintings, *The Three Graces, Orpheus and Euridice,* and *Diana and Her Nymphs Surprised by Satyrs* which in all their richness so characteristic of Rubens, also tell a different story. Each of these paintings depicts the reflections of breast cancer. It is the strict adherence to detail and focus on the individual, so characteristic of the Baroque period, that led Juan Grau and his colleagues in Breast Cancer Research and Treatment in

2001, to speculate that each of these paintings reveals a different aspect of the presentation of breast cancer.

Peter Paul Rubens, *The Three Graces*, Museo del Prado, Madrid, Spain. Photo Credit: Scala/Art Resource, NY.

In the *Three Graces,* the far right model in her left breast displays a tumor that extends from the left upper side of her breast into her left axillary area. There is also retraction of the nipple and the entire size of the left breast seems to be smaller than her right breast. There is redness and irregularity in the tumor in the left breast area. These are perhaps reminiscent of an inflammatory component of breast cancer. This occurs when the tumor actually invades the skin. The entire scenario of findings is totally compatible with a locally advanced breast cancer. In the other two Rubens' paintings, we see another aspect of breast cancer.

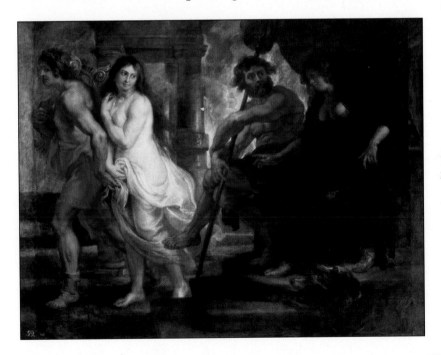

Peter Paul Rubens, *Orpheus and Eurydice,* Museo del Prado, Madrid, Spain. Photo Credit: Scala/Art Resource, NY.

In *Orpheus and Eurydice,* we see an earlier stage of breast cancer. The figure which represents Eurydice shows abnormalities of her left breast. There is also an area of the left upper breast which reveals fullness with redness of the skin. But in this case, there is no retraction of the skin.

Peter Paul Rubens, *Diana and her Nymphs Surprised by Satyrs,* Museo del Prado, Madrid, Spain. Photo Credit: Scala/Art Resource, NY.

In *Diana and Her Nymphs Surprised by Satyrs,* the woman in front with her hands raised, also has a fullness in her left breast with a dimpling of her skin. Here in plain sight, Rubens depicts what every woman can see in the mirror. These are the changes that breast cancer can have long before the ulcerations or the spread of the disease. This is what every woman could easily see. Rubens is giving us a reflection through the eyes of the patient of what exactly they encountered. There is a great deal of power in these individuals. There are no signs of fear or disbelief. These reflections are all out in the open.

One of the most interesting demonstrations of this Baroque philosophy towards breast cancer came from Lucas Vorsterman, an engraver for Rubens. In 2008, Grau and Estrach published a paper in which they used the term "old masters as clinical photographers." The engraving of the *Courtesan Dressed in a Fur and a Hat* by Vorsterman in the Royal Library of Brussels is an engraving of a Rubens painting copied from a Titian painting. The original painting by Titian is lost. What we can see in this engraving is truly shocking. First, we see a beautiful young woman with the right side of her chest totally bare. She is exposing it herself. There in the upper right hand corner of her right breast are two lumps peering out from beneath her skin. There is retraction of the nipple and retraction of the skin all the way up to the axillary area. The way that she positions her hand and fingers as if to deliberately bring attention to her breast and the tumors is truly disarming. Culturally it has always been

taught that to conceal breasts was a sign of modesty, therefore only a physician or artists painting a nude would be able to see ailments or disfiguring traits.

We do not know for sure who the model for the original painting was. We do not know her fate. Some believe that the model was actually Titan's pregnant fiancée or wife. Making these lumps possibly related to some type of mastitis. Though looked at as an oncologist, the depiction by Vorsterman is much more ominous than that of an inflamed or infected milk gland. There is some likelihood that the face here was that of Titan's daughter Lavinia who died 2 years before Titan did. Perhaps, if this was Lavinia, Titan was giving us a reflection of what actually killed his daughter. He was giving us a glimpse of the tragedy that is breast cancer, a disease that until modern times had been thought of as a disease afflicting older women. There was no knowledge of the genetics of this disease. There was no BRCA testing. In fact, there was no science of genetics yet available. Titan immortalized his daughter's ordeal. As Grau and Estrach stated, Titan was not just a painter of everyday life but also a clinical photographer.

Lucas Vorsterman the Younger, *Venetian Courtesan*, 17th century. Etching and engraving.
Photo Credit: The Philadelphia Museum of Art/ Art Resource, NY.

Raphael, La Fornarina, *The Baker Girl.* Ca. 1518, Galleria Nazionale d'Arte Antica, Rome, Italy. Photo Credit: Scala/Art Resource, NY.

Having died a young man at the age of 37, at the pinnacle of his career, Raphael painted for wealthy merchants, popes and kings. One of his most personal paintings hangs in Palazzo Barberini in Rome and depicts his lover, Margherita, or *La Fornarina,* the baker's daughter. The portrait was found in Raphael's studio upon his death, and in his will, written shortly before his death, he made sure that she was well taken care of. Margherita does not embody the Renaissance ideal of beauty which Raphael always worked so hard to perfect. She is bottom heavy and almost homely looking. Her facial features are well defined and she wears a stylish headdress. The stark white alabaster quality of her skin would have been highly prized and clearly within Renaissance ideals. With one arm she covers her middle section with a sheer cloth while the other holds up her left breast for all to see. Her right breast maintains the smooth stone-like quality of the rest of her skin. Her left breast differs greatly. There is no gentle roundness. The dimpling on her left breast is obvious, as is the protruding mass under the skin beginning at the index finger and moving back and down. With her index finger, Margherita points to her ailment. Raphael could have easily chosen to paint Margherita from the opposite side, her healthy breast exposed more. He could have chosen to not paint the obvious reality of her sickness. He could have chosen to cover up his lover with a vast array of clothing, shawls, and accessories. Yet he didn't. In contrast, the viewer's eye is immediately drawn, not only by the composition employed by the artist, but also by the sitter's finger. Is this but the classic pose favored by artists as thought by some authors? Or is it, as thought by Carlos Espinel in the *Lancet,* pointing to the malignancy in the painting, the darkness in *La Fornarina's* life, breast cancer.

One of the recurrent themes during the Baroque period was the transience of life. The idea that life is fleeting and that each person must prepare himself or herself for inevitable death is a powerful theme for many artists. In 1626, Renieri gave us a very special allegory of transience in his painting *Vanitas: Allegory of Transience.*

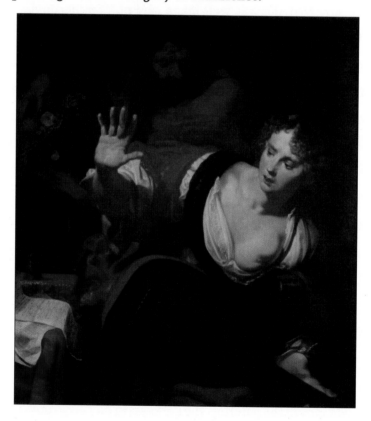

Niccolo Renieri, Vanitas: *Allegory of Transience,* Christian Museum, Esztergom, Hungary.
Photo Courtesy: Keresztény Múzeum, Esztergom. Photograph by Attila Mudrák.

Here, Chronos, the allegorical figure of time startles a young beautiful, rich woman. She is surrounded by items of worldly pleasure but also by a skull and withering poppies symbolizing the mortal or transient nature of all things. But even more revealing is the deformation of the young woman's left breast caused by breast cancer. There is bewilderment in the expression on the face of the young woman. This astonishment is of her own mortality but also perhaps, of the disease that she carries. Is Renieri really trying to prepare those afflicted to be ready for their fate? Was he not just reflecting what every woman might have thought? That their life was going on very well until they were snatched up by the curator of time and taken away from this worldly life by this silent killer known as breast cancer. Such a view gives us a personal diary of each patient all woven into this allegory of transience.

The Baroque era gave us a new understanding of this horrible disease. It tried to give us a firsthand look at what every patient was facing every time she looked at herself. It gave us realistic views of a disease that previously had just been hinted at. It tried to reflect the suffering and yes, perhaps the ways that patients were coping with this disease. Unlike some of the wild theories about its origins as a contagious disease or a reflection of some wrong doing, the artist tried to show us a totally different side of those consumed by this nightmare. These patients were heroic. They had strength. They had beauty. They lived despite this disease until it was too late. Therapy was not a realistic option. Their fate was perhaps

in the hands of the three graces. At this point in time the transience of life especially for those afflicted by breast cancer meant preparation for the ultimate ending. Cure was not yet a word that could be used in the same sentence as breast cancer. Virtue and self respect for the individual was all that could be offered.

CHAPTER EIGHT: CANCER AND THE CONVENT

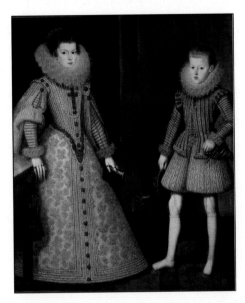

Bartolomé González y Serrano, *The Infanta Ana, Future Queen of France, and her brother, Felipe,* Future King of Spain,

Kunsthistorisches Museum, Vienna. Photo Credit: Erich Lessing/Art Resource, NY.

Anne of Austria (1601–1666) was married to Louis XIII on October 25th, 1615 at the tender age of 14. She became Queen of France and bore two sons, Louise the XIV and Phillipe, Duke of Orleans. Anne was a Hapsburg, daughter of the King Philip III of Spain and her marriage to Louis XIII was known to be an unhappy one. Her life is the setting

for the story *The Three Musketeers,* when dislike for her in the French court grew as France and Spain fought a war against each other and her secret correspondence to her brother, King Philip IV of Spain was discovered. Although she was given her own suite of apartments in the Louvre after marriage, Marie de Medici, Louis' mother, continued to conduct herself as Queen. Anne was a real beauty with blue eyes, chestnut colored cascade of hair, fair skin. Her personality was vivacious and she proved to be an excellent equestrian.

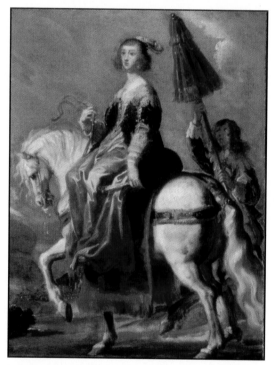

Jean de Saint-Igny, (attributed to) *Equestrian portrait of Anne of Austria.* Chateaux de Versailles et de Trianon, Versailles. Photo: Gerard Blot. Photo Credit: Réunion des Musées Nationaux/Art Resource, NY.

Most of Anne's pregnancies ended in miscarriage and it wasn't until the age of 37, after 23 years of marriage, a pilgrimage to Notre-Dame de Consolation which was deemed miraculous and the curative waters of Vic in Auvergne, that she became pregnant. Louis was born and two years later his brother Phillipe.

At the tender age of four, her son became king, following the death of her husband Louis XIII. Anne became regent of France and proved to be an able ruler, although her husband had tried to limit her authority in his will, limits she quickly had removed after his death. She had a strong and mutually respectful relationship with her son, Louis XIV, King of France, and when he came of age he married her niece, transformed Versailles into the palace it is today and was popularly known as the Sun King. While her son was young, Anne entrusted the government to the chief minister, Jules Cardinal Mazarin, believed to be her lover and possibly secret husband. Louis XIV assumed the throne in 1643 and his mother retired to the convent Val-de-Grace in Paris in 1666 at the age of 64. Anne of Austria would die in the convent of breast cancer, but not before she would undergo numerous barbaric treatments upon insistence of her physicians.

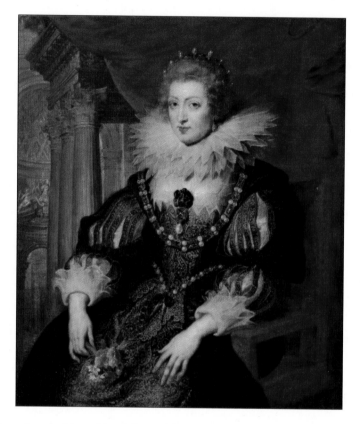

Peter Paul Rubens, *Portrait of Anne of Austria*, Louvre, Paris, Photo Credit: Erich Lessing/Art Resource, NY.

Anne was raised a religious person and continued to be so her whole life. A few years after her marriage, she visited an abbey outside of Paris and met the abbess, Mother Marguerite de Sainte-General, and a deep friendship developed. Anne became very involved with the convent and purchased a piece of land in Paris and built a new structure which be-

came known as Val-de-Grace. She visited with nuns regularly and in 1663 when she felt the lump in her breast she was all too familiar with what she would be facing, having seen many nuns suffer through this illness before. She had seen bandages changed on necrotic tissue and smelt the horror that is wreaked on the body. Madame de Motteville, Anne's close companion, kept an incredibly detailed diary of her life with the queen. She writes of the two women witnessing the damage done by tumors to the nuns' bodies and of Anne's incredible fear of the disease. Unfortunately, Anne's fear and the lack of medical knowledge of the times would be her demise.

Medicine in seventeenth century France was rudimentary at best and based on theories of humors. The humors were bodily fluids all thought to originate in the liver. Blood, phlegm, yellow bile, and black bile were the four humors. Supposedly the level of humors in the body characterized the personality. This was a belief that dated back to Claudius Galen (129–216 AD), who removed some tumors surgically, but generally believed that most cancers should be left untreated. Galen believed that melancholia was the chief factor in causing breast cancer. In the seventeenth century there was no or little knowledge of the necessity of antiseptic procedures. Bloodletting, hot oil, and cautery were the tricks of the trade. Even if a tumor could be removed, most patients died from infection.

While the seventeenth century is often dubbed the age of scientific revolution, the revolution mostly occurs in theories of our solar system in the work of Galileo. There were some

medical advances. Franciscus Silvius applied a more empirical approach to medicine, Van Helmont rejected the theory of humors and felt that the body was water based and William Harvey made brilliant advances regarding the circulation of the blood. Thomas Bartholin, who was the first to describe the lymphatic system, believed that tumors were clotted tissue fluid caused by the blockage of the lymphatic vessels. But perhaps the most important development of this period was the description of the first microscope by Antonie van Leeuwenhoek. Here for the first time, the world of the microscopic universe was about to be revealed. Here in the seventeenth century, an invention would allow physicians to see a whole new reality and allow a new set of hypothesizes to replace the inferences and stigmata of many diseases.

The seventeenth century Dutch physician Andrian Helvetius performed both lumpectomy and mastectomy, claiming this cured breast cancer. German surgeon Wilhelm Fabricius Hildanus (1560–1634) removed enlarged lymph nodes in breast cancer operations, while Johann Scultetus (1595–1645) performed total mastectomies. In seventeenth century France, physician Calude Gendron (1663–1750) concluded that cancer arises locally as a hard, growing mass, untreatable with drugs, and that it must be removed with all its "filaments." At the same time in Italy, Dr. Bernardino Ramazzini (1633–1714) reported the virtual absences of cervical cancer and relatively high incidence of breast cancer in nuns. This observation was an important step towards identifying hormonal factors such as pregnancy

and infections related to sexual contact in cancer risk, and was the first indication that lifestyle might affect the development of cancer. While progress was slowly, very slowly, being made, cancer victims had little or no hope of survival and their only certainty was a future of painful treatments.

When Anne first felt the lump in her breast in 1663 she chose not to seek out treatment. She had already changed greatly since the death in 1661 of her lover Mazarin. She had not taken any part in political affairs for quite some time. She had the happiness of seeing two grandsons born, knowing that Louis had heirs. Her daughter-in-law was a comfort and solace to her in the latter years, and she lived to see peace and tranquility in France.

Given the state of cancer treatment in seventeenth century France, Anne's postponement of medical treatment was not her demise. Cancer patients were doomed from the outset. Anne knew of the cutting, burning, and infection that came along with the medical methods at the University of Paris. Madame de Motteville's accounts of various instances when Anne felt pain in her breast in 1664, eventually lead the queen to be seen by her physician Dr. Seguin. Madame de Motteville wrote:

"The queen-mother for some time past . . . had felt much pain in her breast. As she had too long neglected this aliment, she was astonished to see that in a very short time it had grown worse. . . She had consulted doctors at the beginning of this strange malady, and they

had then applied hemlock . . . The queen-mother, finding succor in no one, was compelled to abandon herself to the wrangling of men who tortured her more than her disease."

Tumors could be removed, but the painful experience was followed only by cautery and infection. Metastasis was also a concern. Surgery was not an option for Anne, her tumor deep within her breast and already spreading up underneath her arm. Louis XIV was deeply concerned with his mother's health and hoped the doctors could assist in her in living as long as possible. Anne only asked for patience granted by God to deal with her disease, knowing full well that there was no cure. Madame de Motteville writes:

(Anne) had often said on other occasions. "God will help me; if he permits that I shall be afflicted with the terrible disease that seems to threaten me, what I suffer will no doubt be my salvation; and I hope that He will give me strength to bear it with patience."[3] She added to these words having seen cancers in the nuns of the Val-de-Grace, who had died all rotten, she had always had a horror of this disease, so terrible in her imagination . . ."

Many remedies were employed and bloodletting became a daily occurrence for Anne. For six months in 1665 Anne had arsenic paste applied to her breast and the dead skin surgically removed, all along as Anne grew weaker, lost weight and fought off a nagging, continuous cough. A local healer, Gendron, attempted a cure, but "the remedy was hot, and consequently violent. The queen-mother felt great pain from it." When there appeared to be no cure, Anne turned to the convent. "On the 27th of May, the queen-mother had a severe

3. Memoirs of Madame de Motteville on Anne of Austria and Her Court. vol. 3. London: William Heinemann, 1903. p. 310

chill . . . that lasted six hours. It was followed by intense heat; after which an erysipelas appeared which covered the arm and shoulder on the side of the cancer." Queen Anne began after this point to put her affairs in order and prepared herself for death, which she felt was making great strides towards her.

It was often thought that nuns died in higher percentage from breast cancer, many believed because of the sexless life they led. What they didn't know at the time was that the unremitting effects of estrogen throughout their lifetime were indeed a predisposing factor in the development of breast cancer. In the twentieth century, it became apparent that if a woman carried a pregnancy to term before the age of twenty seven, that it would incur a benefit and lower the risk of developing breast cancer. The story of Anne's inability to get pregnant and deliver a child until she was 37, added a risk factor to her subsequent disease. This little known tale of the effects of estrogen was something that Anne shared with the nuns. Anne found comfort in those who understood her plight. She prayed for her worldly sins believing that the cancer was a punishment inflicted by God. She, who had once so carefully groomed herself, proud of her beauty, felt it ironic that she should be suffering from a disease that produced such horrific bodily fluid and odor. One can only wonder if she spent her last days in the convent praying to St. Agatha. For three long years she bore her illness with the patience of a saint.

Portraits of Anne are mainly the staple of official royal business. Younger depictions

show the liveliness of youth and the great beauty for which she was often praised. In the painting (1621–1625) by Rubens, Anne is older, yet beautiful with her porcelain white skin firm, her lips turned up in a gentle smile. All of her regal attire does not harden the vibrant person beneath. How things have changed in later depictions of Anne where she is dressed in rather plain clothes, a large Crucifix hanging around her neck or as a widow dressed as a nun. Looking at the paintings one can only wonder how she hid her pain and fear under her garments. She was a real and living woman. Her marriage was not the best, she experienced the joy of children, had the passion of true love with her lover, and suffered through human frailty, disease, and breast cancer.

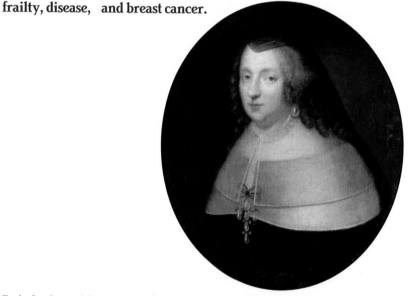

Charles Beaubrun and Henri Beaubrun (1603-1677), Studio of: *Portrait of Queen Anne of Austria* (1601-1666), wife of Louis XIII, wearing a widow's habit. Chateaux de Versailles et de Trianon, Versailles, France Photo: Gérard Blot. Photo Credit: Réunion des Musées Nationaux/Art Resource, NY.

CHAPTER NINE: HYSTERIA OF THE BREAST

Hysteria was a common diagnosis given to women in the Victorian age. Doctors prescribed electrical stimulating machines, the vibrators of today, to relieve anxiety. What to think of breast cancer then? In the Victorian Age, breast cancer was perceived, diagnosed, and untreated. Were women being affected by the industrial age? They were forced to work in factories, no more breast feeding, leaving their babies behind. Was modernization eating away not only at women's spirits and families, but also at their breasts? Were Dr. Halsted's radical mastectomies the only answer in an age when breast cancer was thought to be a form of venereal disease, and victims delayed seeking care until they had advanced breast cancer?

Despite the fact that the head of state in England was a woman, in Victorian England, women were not treated as equals to men. The only acceptable occupation for a woman was marriage and she was groomed from a very young age for this task. Women were expected to know how to sew, play music, and be innocent. They wore a chemise while bathing and were expected to close their eyes to any nudity, even their own. All women were expected to

be weak and delicate, serving husbands and morally raising children. Menstruation was considered something dirty and often cited as the source of a woman's weakness. In 1854, Dr. William Acton's *Functions and Disorders of the Reproductive System* states that female enjoyment of sexual pleasure was due to physical and mental disease. He wrote, ". . . immoderate coitus and excitation are not without importance in the aethiology of cancer . . . it is not the frequency of the coitus but the moral excitation which accompanies it which seems here to be the important point" and a female who masturbated had "a frame that is stunted and weak, the muscles undeveloped, the eye is sunken and heavy, the complexion is sallow, pasty or covered with spots of acne, the hands are damp and cold, and the skin moist."

Spanning 64 years, not all women of the Victorian Era can be lumped together. Until late in the century a married woman could own no property. Then in 1887 the Married Woman's Property Act gave women rights to own her own property. Towards the end of the 19th century, modern inventions such as sewing machines and telephones, as well as more tailored clothing brought about a new kind of woman, one who was beginning to think on her own. Mrs. Amelia Bloomer even invented a new type of undergarment that didn't require the uncomfortable layering of petticoats. These mores were of course for upper class women. Large numbers of working class women, in factories, wore simple clothing and were more concerned with feeding their families rather than the stylish dress of the times.

Towards the end of the century, women were allowed in the medical profession as nurses or worked in office environments. Whether upper, middle, or lower class, all women had one thing in common in Victorian England, they all had to adhere to strict moral codes of repressed sexuality, except for mistresses of course and women of the lower class who resorted to prostitution to feed their families. Should a woman transgress the moral code and possibly have a child out of marriage, she immediately became an outcast. Women were virgins, wives, mothers, or whores. The hypocrisy of the era is astounding. Men, in unhappy marriages with women who were taught that sex was a chore and contained no pleasure, looked elsewhere for satisfaction. The cultural codes appeared noble, but many were living otherwise, shutting their eyes to whatever was ugly or unpleasant.

Queen Victoria, who reigned from 1834 to 1901, had nine children, so it would be safe to assume that she knew something about sex. Everyone in the house had their own bedroom, even husbands and wives. It is possible that this repressed sexuality was in response to the lascivious behavior of the Georgian era before. However, the Victorian era had a strict set of moral standards, and if, as a woman, you stepped out of line, you were humiliated and excluded from society; you received the name "fallen woman."

The female breast throughout the ages has been imbued with deep cultural meanings of motherhood and sensuality and it is perhaps these important attributes assigned to the breast that made disease of the breast such a taboo subject. Victorians did not broadcast

their aches and pains for the world to see. Women may have felt ashamed to discuss their illness and certainly in Victorian times this would have been a difficult subject. The silence surrounding breast cancer was absolute, only few female voices were heard and most only loud enough when describing the horrible treatments suffered through. Our society today has inherited sexual repression from the Victorian age and we are only now beginning to free ourselves from the taboo of speaking about breast cancer.

In ninteenth century England, during the peak of the first industrial revolution, it is estimated that over 75% of deaths were attributed to a single disease: consumption, caused by the acid-filled coal smoke from England's factories and homes. This was combined with a virulent strain of tuberculosis which thrived in England's damp climate and overcrowded tenements. Doctors did not know how to treat the disease and most people considered it their fate that they would die before forty of consumption. There was little or no knowledge of what caused consumption. How then could the medical world understand cancer which develops when cells in a part of the body begin to grow out of control? In the seventeenth and eighteenth centuries, some believed that cancer was contagious. In fact, the first cancer hospital in France was forced to move from the city in 1779 because of the fear of the spread of cancer throughout the city. Percival Pott of Saint Bartholomew's Hospital in London described in 1775 the occupational cancer in chimney sweeps, cancer of the scrotum. This research led to many additional studies that identified a number of hazardous occupations and

led to public health measures to reduce cancer risk. John Hill of London was the first to recognize the dangers of tobacco and in 1761, only a few decades after tobacco became popular in London, he wrote a book entitled *Cautions Against the Immoderate Use of Snuff.* But what about breast cancer?

By the end of the eighteenth century the humor theory first brought about by Galens had begun to lose ground. French physician Jean Astruc compared beef and cancerous breast tissue by cooking them both and eating them, arriving at the conclusion that the breast tissue did not contain large amounts of black bile as had been the belief. The first giant step for the treatment of breast cancer came with the discovery of anesthesia. Though the "Sweet Oil of Vitriol," later to be known as ether, was created by Valerius Cordus in 1540, it wasn't until 1842 that Crawford Long performed the first operation utilizing ether as an anesthesia agent. As important as anesthesia was to modern surgery, the control of infection was an even more important hurdle. Joseph Lister, an English surgeon (1827-1912), noted that 45 to 50% of the patients undergoing an amputation died of a post operative infection. Having read of the work of Louis Pasteur in 1865, Lister emphasized the need for an antimicrobial treatment. Limited to a very primitive antimicrobial agent, phenol, Lister was able to reduce surgical infectious deaths by 15%. His groundbreaking work was published in 1867 in the *British Journal of Medicine.* It would take years and endless controversy for these basic sterile practices to become a new standard of therapy. Only now could mastectomy operations

begin to save patients as opposed to contributing to their demise Three surgeons stand out in their contributions to cancer: Bilroth in Germany, Handley in London, and Halsted at Johns Hopkins. Their work, but most importantly Halsted's work, led to an operation that would remove the breast, the chest muscles below the breast, and the lymph nodes from the armpit

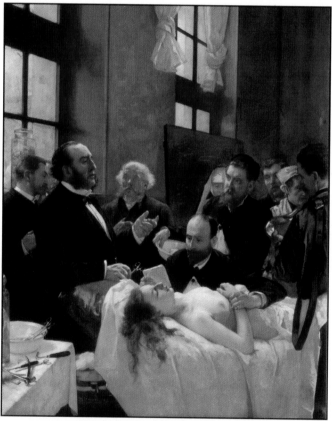

Henri Gervex, *Before the operation,* Dr. Jules Emile Pean (1830-1898) teaching his new technique of artery-clamping at the Saint-Louis hospital. 1887. Musee d'Orsay, Paris Photo: Blot/Lewandowski. Photo Credit: Réunion des Musées Nationaux/Art Resource, NY.

area of that breast tumor. The prevailing theory was that in order to cure a person from breast cancer, the more thoroughly you removed the cancer and all of the surrounding tissue, the more chance a cure could be achieved. Halsted's radical mastectomy became the basis for breast cancer treatment until the 1970's. While different therapies developed, the origins of breast cancer were still very much a mystery.

The most frequently diagnosed cancers were cervical and breast cancer and in Victorian England both were thought to be somehow connected to venereal disease. In 1851, on Christmas Eve, a physician William Marsden brought a sick woman to St. Bartholomew's Hospital in London. He wanted her to receive medical attention, as he noted she was well on her way towards death. She was diagnosed with breast cancer and asked to leave, for breast cancer was considered a venereal disease and that type of illness was not treated at St. Bartholomew's Hospital. The young doctor took her home and he and his wife looked after her until her death the following week. Dr. Marsden eventually purchased the home next door to his and opened a care center for cancer patients that would eventually become Royal Cancer Free Hospital of London, the name of which was changed on the 100 year anniversary in 1951 to Royal Marsden Hospital. There was similar stigmatism across the pond in the U.S. where a special hospital, Memorial Hospital, was founded in 1888 for cancer patients, only eventually to become the Memorial Sloan Kettering of today. Seventy years earlier,

America had experienced one of the better known breast cancer cases in the daughter of John Adams, Nabby Adams. Women's bodies were considered smaller versions of the male body except with the sexual organs on the inside. It was thought that female reproductive health was damaged by intellectual stimulation and disease transmission was thought to occur through inheritance, lifestyle, and mood, with some influence of climate.

Here we turn to the British novelist Fanny Burney. One of Jane Austin's favorite writers, Fanny was not your typical Victorian woman, an author who at first published anonymously, married a French man, and lived in the royal circles of Paris. While she lived her childhood and youth in England, she and her husband moved to Paris after the Revolution, living there for ten years (1802–1812). It was in 1811 that she began to feel pains in her breast. Her husband immediately had her tended to by the best physicians Paris could offer. Her rare narrative, a letter written to her sister nine months after her mastectomy, is a poignant tale of suffering and a cautionary plea to her sisters and nieces not to wait for treatment should they experience any pain in their breast. Fanny was able to recount in great detail her experience of mastectomy which was performed without anesthesia, excluding the cordial she was given to drink prior to the operation. She describes the seven doctors dressed in black that entered her room, the steel knives, the cutting and continuous scraping, her screams and the pale, frightened, bloodied faces of her doctors, all the while as they per-

formed her mastectomy, in twenty minutes. Her letter captures the inner strength of this woman, fighting the good fight.

But things were indeed changing. Anesthesia was becoming a reality. In 1851, Kamata Keishu would publish a surgical treatise called *Geka Kihai*, which documented the work of his mentor and surgeon, Seishu Hanaoka. The 1804 work *The Picture of Breast Cancer*, is believed to describe the first use of general anesthesia for a surgical procedure. In this case, anesthesia was being given through the administration of *Tsusen san*, an herbal mix-

Kamata Keishu, *The Picture of Breast Cancer from the Medical Treatise Geka Kihai*. Photo Courtesy Wellcome Library, London.

ture of mandragore and aconite roots. The picture shows us a woman who seems to be unconscious and unaware of the blood and gore that is being afflicted to her chest. Note carefully that the surgeon is not wearing gloves and is using his hands to dissect out her tumor. No better sterile technique had been invented.

Alice James, sister of the novelist Henry James, suffered mental breakdowns during her life and was diagnosed with female hysteria. An intelligent woman, forced not to think, her mind suffered. It was a common Victorian view that women were vulnerable to insanity and hysteria because their reproductive system interfered with rational thought and emotions. To cope, she began a journal in 1889 and kept it until her death from breast cancer in 1892. She found freedom in her writings, although her medical history was one of constant breakdowns and treatments. She was sent to rest in Massachusetts one year and received electrical treatments in New York another. She wrote: "One has a greater sense of intellectual degradation after an interview with a doctor than from any human experience." While the diary was meant to be private, it was published after her death and the death of Henry James. The play, *Alice in Bed,* based on her life, opened in 2000. After Alice was diagnosed with cancer and too sick to write, her longtime friend, Katharine Loring, moved in and took dictation. While cancer is what she died from, the true tragedy of her life is that she was born during a time when women were only allowed to think about marriage and family.

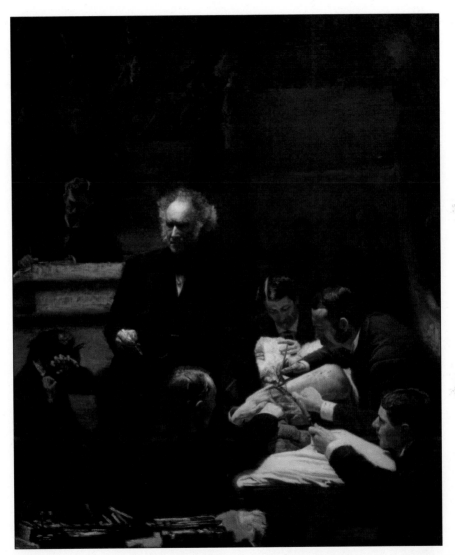

Thomas Eakins, *Portrait of Dr. Samuel D. Gross (The Gross Clinic)*, 1875, Philadelphia Museum of Art, Philadelphia, PA.
Photo Credit: The Philadelphia Museum of Art/ Art Resource, NY.

On the heels of this scientific revolution, Thomas Eakins would depict the real patient. The *Agnew Clinic* depicts a real operation. Prior imagery such as *The Anatomy Lesson of Dr. Tulip*, never included a bit of real surgery. They showed us a postmortem exam where there was no

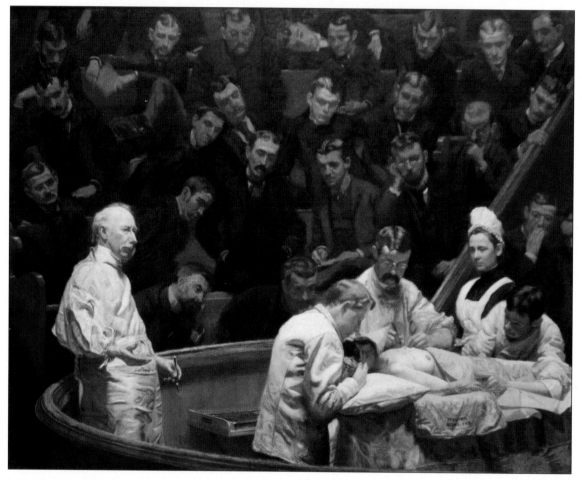

Thomas Eakins, *The Agnew Clinic*, Philadelphia Museum of Art, Philadelphia, PA. Photo Courtesy The University of Pennsylvania Art Collection.

real surgery being done, just a demonstration on a corpse. Even the face of the cadaver is hidden in a shadowy veil, removing identity. In the art of Eakins, we see the amazing changes that were happening in medicine. In 1875, Eakins painted *The Gross Clinic*. The painting depicts the work of Dr. Samuel Gross at Jefferson Medical College. It was initially painted in 1875 and submitted to the 1876 Centennial Exhibition in Philadelphia and rejected for exhibit because it was thought to be too bloody and too realistic. A painting of paradoxes, it depicts surgery on the leg of a young man who reportedly had osteomyelitis, an infection of the bone. Amazingly, the procedure is not an amputation as would have been expected just a few years earlier. This is a much more conservative surgery. The painting reflects a new image for surgery, that of a healing art rather than just one of amputations and disfigurement. However, this painting also brings to light the failure of the spread of antiseptic procedure and sterile technique. Here we see Dr. Samuel Gross and his students all in street clothes, in a dark amphitheater, performing surgery with their bloody bare hands. Fourteen years after painting *The Gross Clinic*, Eakins would produce *The Agnew Clinic*. In the later, the physicians are all dressed in their surgical gowns. There is even a nurse in attendance. The operating hall is bright and the sense of an antiseptic technique abounds. The legacy of Lister's work is now evident. Touchingly, the surgery that he chose to reflect was that of a mastectomy.

The shift from the beginning of the Victorian era with its misconceptions of venereal disease, to the latter part of the Victorian era when science is finally progressing can be seen in the

John William Waterhouse, *The Hamadryad*, Plymouth City Museum and Art Gallery. Photo courtesy©Photo Plymouth City Museum & Art Gallery.

changes in medical depictions in art where the human condition and the therapy needed to make it better are now center stage. By the end of Victoria's reign, art was obsessed with the nude female figure and there was an emergence of pornography after improved photography technology in 1835. The shift in art reflects the shift in a woman's position in society as well. There was a need for women in the work force brought on by the Industrial Revolution and along with skilled paying jobs came independence and some level of emancipation. By 1880 habits had changed and women were playing tennis, riding bikes, and even given their own key to the door of their home so they could come and go as they pleased. Women were slowly coming out of unhappy marriages, the beginning of a newly vocal generation, and, however small, each step towards gender equality meant a diminution of male power and privilege. Classical and mythological subject matter became vehicles through which to depict alluring female nudes, such as Waterhouse's depiction of *Hamadryad*, a spirit of nature. While the status of women in society progressed, cancer therapies and cures moved slowly. With the condemning mores of Victorian society slowly dying, so too the stigma of breast cancer as a venereal disease would eventually pass and with the turn of the century new therapies would progress.

Science and art were colliding with the social revolution that came with the industrial age and the ending of the Victorian era. Science had given every woman the hope that breast cancer could be treated. Anesthesia would eventually allow surgical procedures to be given without tortuous consequences. Surgery was now grasping at the mechanisms of the spread of disease

and the concepts of the control of its recurrence. Artists now reflected a totally different image from that of prior generations. Instead of hidden features of a departed patient on the postmortem table, we now see the patient exposed and being treated. Instead of hidden meanings and veiled diagnosis, the face of breast cancer was now exposed. We now could use the word and see its treatments, even if just in the artist's brush stroke.

CHAPTER TEN: A NEW THERAPY

There has been a revolution in science in the twentieth century. Not only in oncology which really was not recognized as a subspecialty until the latter part of that century, but in all aspects of medicine. Today, can you possibly conceive of a world in which the concept of antibiotics was totally foreign? Could you imagine a world in which the simplest of surgeries was froth with the complications of anesthesia and postoperative infections? This was the beginning of the twentieth century. Though science was emerging from the shackles of ignorance, there were whole new worlds ready to explode on the horizon. We would finally emerge from the cloak of infectious disease by the work of Fleming. Antibiotics freed the human psyche from the fear that a routine infection could turn into a mortal disease. The plagues of mankind, so feared in the ancient world, could now be erased by the use of penicillin. Imagine that during the American Civil War more men died of dysentery and infection than by gunshot wounds. Antibiotics were truly miracle drugs. The discovery of a vaccine against polio freed humanity from a disease that had scared and disfigured since the beginning of time. To think that by a simple inoculation, the last traces of this scourge could be driven to the ends of the earth. There was hope on the horizon. The work that was

started by Halsted was now being adopted worldwide. Anesthesia, which had been pioneered by Lister, took the place of barbaric principles that made the patient feel like they were being tortured and not cured. A whole new field was emerging known as radiation therapy. Pioneered by a woman, Marie Curie, and her husband Pierre, the world of radioactivity and ultimately radiation therapy in the early twentieth century began to emerge. Could it be more ironic that the person most involved and noted for the development of the science of radioactivity was a woman? She would not only share the Nobel Prize in Physics

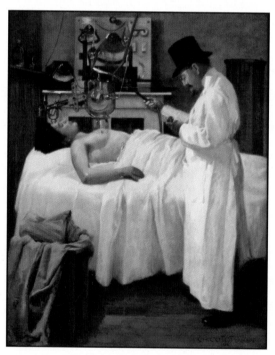

Georges-Alexandre Chicotot, *1st Breast X-Ray*, Musee de L'Assistance Publique, Paris. Photo Credit: Bridgeman-Giraudon/Art Resource, NY.

in 1903 with her husband but would also share the Nobel Prize in Chemistry in 1911. The day of considering women as a second class citizen or being criticized with a moral cast system was about to come to an end. The dawn of science as we know it was about to emerge. The human spirit for women was about to blossom in many ways. Socially, economically, politically, and in the arts, women were now being seen in a totally different light.

So too with art, the revolution that was being seen in science was now taking hold in the art world itself. Was art leading science or science leading art? The advent of the American impressionists, closely studying the science of how the eye interprets the world, developing out of the realism of Eakins, would give rise to the world of the modernists like Picasso and futurists like Balla, capturing movement, physics, on the canvas or in a sculpture. Art was no longer transfixed to the rigid conformity of prior ages. There were no limits. The rulebook had been thrown away. The artist was liberated by the sense of expression and development far greater than any generation before. The mood and the subject matter could now be tailored by the experiences that the artist actually felt. The world of science had opened the door of hope. The artists were now jumping threw it.

The 1960's was a time of a great rebirth in the sciences and in the arts. A little known field was about to rise out of the darkness and destruction of two world wars. What was once used as a gas to kill troops, nitrogen mustard, was now being thought to be a killer of cancer. The tools of destruction were being turned into the tools of saving. The devastating

effects of radiation that where seen at Hiroshima now could be harnessed into the rays of

hope to destroy tumors. Centers of cancer care began to spring up across the nation. The

Memorial Sloan Kettering, the Sidney Faber Institute, the MD Anderson Cancer Center, the

Ken Currie © *Three Oncologist: Professor RJ Steele, Professor Sir Alfred Cuschieri and Professor Sir David Lane of the Department of Surgery and Molecular Oncology, Ninewells Hospital, Dundee,* Scottish National Portrait Gallery, Edinburgh, Scotland. Photo Courtesy National Galleries of Scotland.

Roswell Park Institute to name a few, became the beacons for research and hope in a disease that before was without mention. Cancer had always been an ugly word. So despised and feared that often patients and their families refused to even say the word. The cast of fear and even self-depreciation became part of the burden that every patient carried.

What we had seen in the time of Theodora or seen in the reflections of Bathsheba was still present. The cause of this disease was still not understood. But something was happening. A crack in the dam was about to occur. First, it came in the field of childhood leukemia. In the 1950's and 60's this was a disease with a mortality of over 90%. But the work that emanated from the institutions mentioned above started a whole new prospect for these young patients. It turned them from patients to survivors. It changed the perspective of a disease in which most persons would normally die of its complications to a disease that could be cured in over 50% of the time. The miracle drugs that attacked the infectious plagues of mankind were now turning into the miracle drugs that could save humanity from cancer. Could this possibly be? Could mankind really step out of the darkness of the shadows of ignorance and start making its way into the sunlight of success? Could all the reflections given over centuries of suffering finally give way to another image?

The 1960's have always been noted as a time of great social upheaval. The civil rights movement hallmarked a time of great hope and triumph of the human spirit over the chains and restrictions of inequality, bigotry, and discrimination. This social upheaval was not just

racial in nature. Women were at the center of this upheaval, no longer relegated as second-class citizens of a male world. Their voices and their images reflected loud and clear through the changes that were emerging in many arenas and fields throughout this country and

Deena Metzger: *The Warrior.* Photo courtesy Donnelly/Colt.

throughout the world. In business, government, science, and in the arts the face of woman-hood emerged from under the covers of fear, bigotry, and evil. Their diseases could no longer be forgotten. Their diseases could no longer be thought as venereal disease or diseases caused by their own wrong doing or diseases that were forbidden to discuss. They too had a place in the sun. Every woman had the right to health and wellness. Every woman had the right to be heard and seen. Their fate could no longer be relegated to the world of divine intervention. Their world could neither be hidden under Theodora's cloak nor the smile of *La Fornarina* nor the glimpse of Bathsheba nor acceptance of Michelangelo's *La Notte.* The age of everywoman was now here! The social, artistic, scientific revolution of the latter part of the twentieth century was a runaway railroad train headed straight at breast cancer. There was no stopping this train now. What had been sent into progress could never be sent back. What had taken centuries for artists to characterize now lay the framework for a whole new set of artists to personalize and reflect a whole new tale. The subject matter had no longer to be kept a secret. The disease could no longer be kept silent. The fate of the afflicted could no longer be isolated to votives left at the foot of the altar. There was a breath of hope that came just from the freedom of their new found civil rights. There was hope coming from the world of science that their suffering did not have to be.

Look at the images from the artists of the twentieth century. Could anything more demonstrate triumph and be more liberating than *The Warrior* by Deena Metzger?

Beauty Out of Damage by Matuschka. Photo Courtesy "Beauty Out of Damage" © 1993 all rights reserved. (www.matuschka.net)

The images shout out the freedom, the power, and the triumph of the patient over breast cancer. They yell out loud that there is hope and that the face of breast cancer need not be ashamed, as in the self portrait by the artist Matuschka, *Beauty Out of Damage,* where her single breast body is portrayed as sensual and gorgeous.

The artist is the patient and the patient is the survivor. They speak volumes about the conquest of this disease. They illustrate the marked evolution of not only the treatment of

this disease but also, how every woman can feel about her disease. Could this be just unfounded optimism? Could the freedom of the twentieth century have gone to the heads of the artists without any check of reality? Or could this be much more? Could once again the artist reflect the human condition and also the scientific progress that was taking place in the world of oncology? We think it does.

The latter part of the twentieth century was the beginning of a whole new field of medicine known as oncology. As bizarre as it might seem that in the early part of the twentieth century there were no real antibiotics, it wasn't until the latter half of that century that there were real medicines against cancer. What started out as basic science experiments in mice and laboratory animals in the 40's and 50's, turned into the life saving drugs of the 80's, 90's, and the twentieth century. The surgery of breast cancer did not radically change from the days of Halsted until another leap of fate occurred. Stuck in the concept that more surgery equals more chance for cure, the oncology world was rocked with the idea that less surgery might be just as curative but with less disfigurement. Imagine the patron saint of mastectomy needing to be replaced by the patron saint of lumpectomy! Imagine that if one could spare a woman's breast and keep her beauty less altered without sacrificing her chances for cure how incredible this might be. This is exactly what happened in the 1980's and 90's. The paradigm of Halsted was abandoned for most patients. A new age had surely

begun. The fate that had driven Theodora to secrecy was finally over. But this was only the beginning.

The discovery and refinement of diagnostic tools such as mammography and then sonography and now MRI imaging of the breast started a totally new concept of finding a disease before it had a chance to spread and harm a patient. No longer were the images that we have seen through the centuries of far advanced breast cancers the norm. Women could now be diagnosed at a stage that was microscopic in nature. These are not the tumors that peak out from behind the robes or dimple the skin or pucker the nipple. These are tumors only recognizable by the radiologist's magnifying glass peering at calcifications on a mammogram. The terrorist could be seen lurking in the foreground before having a chance to explode the cancer bomb. The hidden veil of cancer was being cut apart. The image on the diagnostic radiologist screen reflects a whole new world, a world never seen before and one which is being redefined almost every day.

Unfortunately, the hope of finding a cancer before it has spread is a reality for most but not all of the patients with breast cancer. Despite our present attempts, there are still too many women who are challenged by this tyrant. But that too is changing. Chemotherapy, which simply means medicines designed to fight cancer, are really false building blocks of DNA. Their use has had a multitude of implications. First in childhood leukemia, then in Hodgkin's disease, Hairy Cell leukemia, testicular cancer, and now in breast cancer,

chemotherapy can be curative in many cases and controlling of the disease in many more cases. In breast cancer, it can be used as a preventive means known as adjuvant therapy. For those women who have a high risk of recurrence after surgery is done, adjuvant chemotherapy can cure if not delay the return of their disease. In those patients in whom the disease has spread, chemotherapy can give years of control over this situation. But in the twenty first century, chemotherapy has given way to a whole new field, biological or targeted therapies. Medicines are designed to be a smart bomb, only hitting their target and sparing good tissues and organs. Medicines like Herceptin and Avastin seek out malignant cells and stop their ability to spread and grow blood vessels. This is personalized therapy, each cocktail of treatment being designed specifically towards the individual patient and their disease. Just like the artistic portraits, the patient is front and center. The individual so afflicted can stand tall and survive.

Science has made us understand this disease. We know what drives it. We can turn away its food chain by using medicines like Tamoxifen or Fasolodex which are anti-estrogens. Or we can build highly sophisticated medicines such as aromatase inhibitors like Arimdex, Femara, or Aromasin that can pinpoint a single enzyme that allows a tumor cell to make its own estrogen. We can now draw a simple blood test that can measure two genes, BRCA 1 and 2, which gives the afflicted person a very high chance of developing breast and ovarian cancer, even before they have these diseases. Some of the images seen through the centuries

depict young women as the afflicted patients. Is not breast cancer a disease of older women? Does not most breast cancers occur in women over the age of 50? Did the artists take liberties in describing their models with this disease? Or did these artists, even before the concept of genetics was considered, recognize whether gene mutations such as BRCA 1 & 2 existed in a patient? Did this work reflect a fate that was silently hurting even the young? The images that artists through the centuries conveyed were truly for every woman. It was for the young and for the old. It took over 5,000 years to bring science up to the same point that artists had been depicting all along.

The artists are right. This is not foolish optimism. This is a reality discovered by science and portrayed in art: the human condition, the conquest of disease, the hope of tomorrow, the prayer of deliverance. All of this is shown in the paintings, the sculptures, and the photographs. All of these are reflections of the breast that have evolved through the centuries. They reflect the hopes and prayers of countless millions of whom prior artists gave us a brief but accurate image. They reflect the prayers, hopes, and struggles of every woman who has ever faced this horrible disease. These reflections are for all of them.

We would like to give you two further images. The first is a votive that came from Dr. Michael Baum. He found it a few years ago being sold near a church in Naples, Italy.

Votive purchased by Dr. Michael Baum outside a church in Naples, Italy.

It reflects what the Egyptians, Greeks, and Romans did centuries ago. It reflects the prayers, suffering, and endurance of patients that still today need further help in fighting this disease. This somber reflection tells us that the struggle against breast cancer is not yet over. We have made amazing progress, but there is so much more road to be travelled. We leave you with one final reflection.

This internationally known symbol, a votive to the courage, hope, resilience, and some-day, a cure, has found its way into every aspect of our media and culture. The artists now show this symbol, this votive, in every possible way. It asks not of just divine intervention. It prods science and all mankind to never let up until there is a cure, a cure that will be for every woman and every man that is afflicted by this dreadful disease. That final reflection can not come soon enough, but until then, art will tell of this journey, those who travel it, and hopefully, of those who were cured.

Francis P. Arena, M.D., F.A.C.P.

Tanya Bastianich Manuali, Ph.D.

Breast Cancer Ribbon. Photo Credit: Fotosearch.

AUTHOR BIOGRAPHIES

Tanya Bastianich Manuali dedicated herself to the study of Italian Renaissance art during college years at Georgetown and earned a masters degree from Syracuse University and a doctorate from Oxford University. Living and studying in many regions of Italy for seven years, she taught art history in Florence, and also met her husband, Corrado Manuali, a law student from Rome. In recent years, Tanya co-created Esperienze Italiane, a custom tour company devoted to the discovery of Italian food, wine ,and art. She has also led the development of the website Lidia'sItaly.com, and related publications and merchandise lines. She is a driving force in the production of Lidia's Italy, the Public Television series. Tanya lives with her husband and children, Lorenzo and Julia, in Long Island, New York

Francis P. Arena, M.D., F.A.C.P. is a product of Memorial Sloan-Kettering Cancer Center of New York City. Dr. Arena received his B.S. from Fordham University and his M.D. from Cornell University Medical College. His internship and residency were carried out at New York Hospital/Memorial Hospital, after which Dr. Arena served as chief medical resident and later as Hematology/Oncology Fellow. He is board certified in internal medicine and in medical oncology. Today Dr. Arena is clinical assistant professor of medicine at New York University and adjunct clinical assistant professor of medicine at Cornell University Medical College. Dr. Arena helped establish the SASS Foundation for Medical Research, which supports medical fellows at a number of hospitals. He is on the advisory board of "1 in 9," the Breast Cancer Coalition. Dr. Arena is widely published and has lectured extensively in his field. He has been the recipient of multiple awards and citations for his work in oncology and breast cancer. Dr. Arena lives with his wife and children in Long Island, New York.

BIBLIOGRAPHY

Adams, Ann Jensen, ed. Rembrandt's Bathsheba Reading King David's Letter. United Kingdom: Cambridge University Press, 1998.

Ajnantis, J.; Geroulanos, S.; Kappas, A.; Malliou, S. "History of Mastectomy." Hellenic Medicine. May 2006: 260-278.

Allen, James P., The Art of Ancient Egyptian Medicine. New York: Metropolitan Museum of Art, 2005.

Allen, May. "The Left Breast of Michelangelo's Statue of Night." ‹http://graphics/stanford.edu/courses/cs99d-01/ projects/breast-of-night/ Breast-of-night.htm› 23 January 2009.

Allen, Peter Lewis. The Wages of Sin: Sex and Disease, Past and Present. Chicago: The University of Chicago Press, 2000.

"Anatomy Acts – 1 Roman sculpture of pagan votive offerings (breast and penis)" http://www.anatomyacts.co.uk/ exhibition/object.asp?objectnum 1&search &pageNum 1

"Ancient Egyptian Medical Papryi." ‹http://indigo.ie/~marrya/papyri.html.› 11 July 2008.

"Asklepios." Available at: http://www.theoi.com/Ouranios/Asklepios.html

Baizley, Darrell. "A Biography on Rembrandt, 17th Century Painter." 2002. 18 August 2009.‹ http://www.essortment.com/all/rembrandtbiogra rnow.htm ›

Baum, Michael. "Breast Cancer Treatment Throughout the Ages." Medwire Prime. ‹http://medwire-prime.com/expert comment/breast cancer treatment through the ages.html› 18 August 2009.

Baum, Michael. Letter. The Lancet. 29 March 2003. Vol. 361.

Blum, Linda. At the Breast: Ideologies of Breastfeeding and Motherhood in the Contemporary United States. Boston: Beacon Press, 1999.

Bourne, RG. "Did Rembrandt's Bathsheba Really Have Breast Cancer?" The Australian and New Zealand Journal of Surgery. 2000, 70. p. 231-232.

Braithwaite, PA, Shugg D. "Rembrandt's Bathsheba: the Dark Shadow on the Left Breast." Annals of the Royal College of Surgeons. 1983. 65. p. 337-339.

"Breast Cancer Survival." The Strathfield Breast Centre. http://www.tsbc.com.au/tf.html

Breasted JH, editor. The Edwin Smith Surgical Papyrus. Chicago, IL: the University of Chicago Press; 1930, Special Edition. 1984. The Classics of Surgery Library. Division of Gryphon editions, Ltd. Birmingham (AB). Frontispiece.

Brophy, John. The Human Face. New York: Prentice Hall, 1946.

Brundin, Abigail. Vittoria Colonna and the Spiritual Poetics of the Italian Reformation. United Kingdom: Ashgate, 2008.

Brundin, Abigail, ed. Vittoria Colonna: Sonnets for Michelangelo. Chicago: The University of Chicago Press, 2005.

Bruden, George M., "Ancient Egyptian Medicine." Ancient Egypt Magazine. Vol. 6: 2005.

Czeizel, Andrew E., Letter. The Lancet. 29 March 2003. Vol 361.

David, Rosalie. "The Art of Healing in Ancient Egypt: A Scientific Reappraisal." The Lancet Oncology. Vol. 372: 1802-1803.

Donegan, William L.; Spratt, John Jr., Cancer of the Breast. Philadelphia : Saunders, 1979: 2-4.

"The Edwin Smith Surgical Papyrus." ‹http://www.aldokkan.com/science/Edwin smith surgical papyrus.htm› 11 July 2008.

"The Edwin Smith Papyrus." Medicine in Ancient Egypt. ‹http://www.indiana.edu/~ancmed/egypt.HTM. › 25 July 2008.

Espinel, Carlos H., "The Portrait of Breast Cancer and Raphael's La Fornarina." The Lancet. Vol. 360: 2061-2063.

Espinel, Carlos H., "Delayed Diagnosis." ‹http://bowietrek.typepad.com/bowietreks/2005/06/delayed diagnos.html› 28 July 2008.

Estape, Jorge; Grau, Juan J.; Diaz-Padron, Matias. "Breast Cancer in Rubens Paintings." Breast Cancer Research and Treatment. July 2001: 89-93.

Estrach, Teresa; Grau, Juan J., "Old Masters as Clinical Photographers: Multifocal Breast Cancer Diagnosed 400 Years Ago." Breast Cancer Res Treatment. 2008. 111:11-13.

Farag, Talaat I., "The Unveiled Ebers Papyrus." The ambassadors.net. Vol. 8 Issue 1. January 2005. ‹http://ambassadors.net/archives/issue17/selectedstudy4.htm › 25 July 2008.

Fineman, Mia. "Raphael's Other Woman." ‹http://www.slate.com/toolbar.aspx?action print&id 2113044› 20 January 2009. Gerszten, Peter C.; Gerszten, Enrique; Allison, Marvin J. "Diseases of the Spine in South American Mummies." Neurosurgery. January 2001: 208-213.

Gibson, Gayle. "Names Matter: The Unfinished History of the Niagra Falls Mummies". ‹http://www.egyptianmuseum.com/article10a.html. 18 August 2009.› 18 August 2009.

Gjorgov, Arne N., "Breast Cancer Death of Empress Theodora." 29 December 2006. http://www.makedonija.com/mic/vesti.php?pn detail&id 696 25 July 2008.

Haagensen, C.D. "Physicians' Role in the Detection and Diagnosis of Breast Disease." Diseases of the Breast. Philadelphia: W.B. Saunders, 1986, p. 516-576.

Hajdu, Steven I., "Medievel pathfinders in surgical oncology." Wiley InterScience. ‹http://www3.interscience.wiley.com/cgi-bin/fulltext/109565176/Main.html,ftx abs› 19 May 2008.

"Healer Cults and Sanctuaries." University of Virginia Health System. ‹ http://www.hsl.virginia.edu/historical/artifacts/antiqua/healercults.cfm

"The History of Breast Cancer — Fighting the Most Common Cancer In Women." 19 July 2006. ‹http://www.syl.com/articles/thehistoryofbreastcancerfightingthemostcommoncancerinwomen.html › 29 June 2008.

"The History of Cancer." 11 July 2008. http://www.bordet.be/en/presentation/history/cancer e/cancer2.htm

Jones, Jonathan. "Hendrickje Stoffels, Rembrandt (c. 1654–60)". 4 August 2001. 23 Janurary 2009. ‹http://www.guardian.co.uk.›

Kousiounis, Kerry. "Dream Healing: Asclepius and Dream Healing." ‹http://www.experiencefestival.com/a/Dream Healing/id/5848› 14 July 2008.

Lapham, Lewis. ed. "Mastectomy." Lapham's Quarterly: Medicine. Vol. II, no. 4, Fall 2009. p. 138-139.

Leadbetter, Ron. "Asclepius." Encyclopedia Mythica. 14 July 2008.

Mininberg, David T., "The Museum's Mummies: An Inside View." Neurosurgery. July 2001: 192-199.

Motteville, Madame de. Memoirs of Madame de Motteville on Anne of Austria and Her Court. Vol. 2. London: William Heineman, 1903.

Motteville, Madame de. Memoirs of Madame de Motteville on Anne of Austria and Her Court. Vol. 3. London: William Heineman, 1903.

Nirit Ben-Aryeh, Debby. "Vittoria Colonna and Titian's Pitti Magdalen." Woman's Art Journal. Vol. 24. No. 1 (Spring-Summer, 2003), p. 29-33.

Nunn, John. Ancient Egyptian Medicine. London: British Museum Press, 1996.

O'Connor, Erin. Raw Material: Producing Pathology in Victorian Culture. Durham: Duke University Press, 2000.

Olson, James. Bathsheba's Breast: Women, Cancer & History. Baltimore: John Hopkins University Press, 2002.

Olson, James S., "Bathsheba's Breast: Women, Cancer and History." Breast Cancer Action. 2003. 11 July 2009. http://www.bcation.org/index.php?page newsletter-77f

Riding, Alan. "In Raphael Exhibition, Women Do the Talking." *The New York Times*. 29 December 2001. 20 January 2009.

Rosenzweig, W. "Disease in Art: A Case for Carcinoma of the Breast in Michelangelo's La Notte." Paleopathol News. 1983. 41. p. 8-11.

Ross, Greg. "La Fornarina." ‹http://www.futilitycloset.com/2007/01/03/La-fornarina/› 28 July 2008.

Ruggiero, Guido. "Sexual Criminality in the Early Renaissance Venice, 1238-1358." Reflections on World Civilizations. Vol.1 .New York: Harper Collins, 1993.

Schaefer, Steven D.; Shaner, Arlene; Stiefel, Marc. "The Edwin Smith Papyrus: The Birth of Analytical Thinking in Medicine and Otolaryngology." Find-Health-Articles.com. 30 January 2006. 4 June 2009.

Stark, JJ, and Nelson, JK. "The Breasts of 'Night': Michelangelo as Oncologist." New England Journal of Medicine. 2000. 343. p. 1577-8.

Stark, M.D., James J., Letter. The New England Journal of Medicine. 23 November 2000. Vol. 343.

Strauss R, Marzo-Ortega H., "Michelango and Medicine." Journal of the Royal Society of Medicine. May 2003; Vol. 96: 256.

Strauss R, Marzo-Ortega H., "Michelango and Medicine." Journal of the Royal Society of Medicine. 2002; Vol 95: 514-515.

"The Temples and Cult of Asclepius." ‹http://dodd.cmcvellore.ac.in/hom/05%20-%20Temples%20Cult.html› 11 July 2008.

Vaidya, Jayant S., "Breast Cancer: An Artistic View." The Lancet Oncology. Vol. 8.Issue 7, July 2007: 583-585.

Vaidya, Jayant S., "Locally Advanced Breast Cancer in a 15th Century Painting in Milan." The Breast. vol. 16. 2007. pg 102-103.

Wilkins, Robert H., "Neurosurgical Classic — XVII Edwin Smith Surgical Papyrus." Journal of Neurosurgery. March 1964: 240-244.

Wolff, J. The Science of Cancerous Disease from Earliest Times to the Present. Science History Publications, 1987. P. 3-45.

Yalom, Marilyn. A History of the Breast. New York, Ballantine Books, 1997.

ILLUSTRATIONS

Cover
Francesco Guarino (Solofra 1611-Gravina di Puglia 1651). Saint Agatha, oil on canvas, 112.5 x 77 cm, Private Collection, Rome, Italy. Photo Courtesy Bloomsbury Auctions.

* L. Heister, Latent or Occult Breast Cancer. Photo Courtesy Wellcome Library, London.

* Etruscan Votive Sculpture, terracotta model of a womb, breast, eye and ear all dedicated at the shrine of a healing god. Photo Credit: The Trustees of the British Museum/Art Resource, NY.

* Grotesque torso, breast deformed by a tumor. Terracotta, from Izmir, Turkey. Photo: Christian Larrieu. Photo Credit: Réunion des Musées Nationaux/Art Resource, NY.

* Edwin Smith Papyrus, case 45, Rare Book Room New York Academy of Medicine Library. Photo Courtesy The New York Academy of Medicine Library.

* Sebastiano del Piombo, The Martyrdom of Saint Agatha, 1520. Galleria Palatina, Palazzo Pitti, Florence, Italy. Photo Credit: Scala/ Ministero per i Beni e le Attività Culturali/Art Resource, NY.

* Giovanni Lanfranco, Saint Peter Healing Saint Agatha in Prison, Galleria Nazionale d'Arte Antico, Rome, Italy. Photo Credit: Scala /Ministero per i Beni e le Attività Culturali/Art Resource, NY.

* Bernardino Luini, Saint Agatha, Chiesa di San Maurizio Al Monastero Maggiore, Milan, Italy. Photo Credit: Photoservice Electa Mondadori/ Art Resource, NY.

* Il Cerano, The Madonna Delivers Milan from the Plague, Santa Maria della Grazia, Milan, Italy. Photo: Mauro Ranzani. Photo Credit: Scala/ Art Resource, NY.

* Il Cerano, Miracles of St. Charles: Miracle of Beatrix Antonio Crespi. Margherita della Guardia Veneta, Museo del Duomo, Milan, Italy. Photo Credit: Photoservice Electa Mondadori/Art Resource, NY.

* Giovanni Cariani, Saint Agatha, National Gallery, Edinburgh, Scotland. Photo Courtesy National Galleries of Scotland.

* Theodora's Court - detail. Bust of Theodora, mosaic, San Vitale, Ravenna, Italy. Photo Credit: Scala/Art Resource, NY.

* Theodora and her retinue, mosaic, San Vitale, Ravenna, Italy. Photo Credit: Scala/Art Resource, NY.

* The Anatomy Lesson given by John Banister (1533-1610) at the Barber Surgeons Hall in 1548. Fontispice of 'De re anatonomica' by Matteo Realdo Colombo (Renaldus Columbus) (1516-1559) ca. 1580. Bibliotheque Nationale, Paris. Photo Credit: Scala/Art Resource, NY.

* Jan the Younger Grevenbroeck, Masked doctor during the plague in Venice, from the Grevenbroeck manuscript, 17th century, Museum Correr, Venice, Italy. Photo Credit: Erich Lessing/Art Resource, NY.

* William F. Yeames, Death of Amy Robsart, exhibited 1877, Tate Gallery, London. Photo Credit: Tate, London/Art Resource, NY.

* View of the interior of the New Sacristy, Basilica of San Lorenzo, Florence, Italy, designed by Michelangelo Buonarroti (1475-1564). Photo Credit: Alinari/Art Resource, NY.

* Michelangelo Buonarroti, Tomb of Giuliano de Medici, Duc de Nemours (1479-1516). 1519-1534. Post-Cleaning. Basilica of San Lorenzo, Florence, Italy. Photo Credit: Scala/Art Resource, NY.

* Michelangelo Buonarroti, detail of Night from the tomb of Giuliano de Medici, Duc de Nemours (1479-1516). 1519-1534. Basilica of San Lorenzo, Florence, Italy. Photo Credit: Erich Lessing/Art Resource, NY.

* Michelangelo Buonarroti, close up of breast in Night from the tomb of Giuliano de Medici, Duc de Nemours (1479-1516). 1519-1534. Basilica of San Lorenzo, Florence, Italy. Photo Credit: Alinari/Art Resource, NY.

* Michelangelo Buonarroti , Studies for the Libyan Sibyl (recto). 1508-1512. Red chalk (recto), 11-3/8 x 8-7/16 in. (28.9 x 21.4 cm). Purchase, Joseph Pulitzer Bequest, 1924 (24.197.2). Metropolitan Museum of Art. Photo credit: Image copyright The Metropolitan Museum of Art/Art Resource, NY.